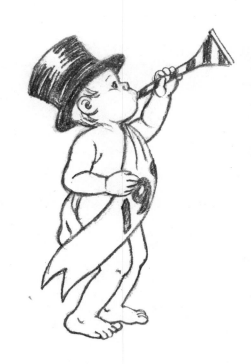

Other books by Lee J. Ames:

DRAW 50 ANIMALS

DRAW 50 BOATS, SHIPS, TRUCKS, AND TRAINS

DRAW 50 DINOSAURS AND OTHER PREHISTORIC ANIMALS

DRAW 50 AIRPLANES, AIRCRAFT, AND SPACECRAFT

DRAW 50 FAMOUS FACES

DRAW 50 FAMOUS CARTOONS

DRAW 50 VEHICLES

DRAW 50 BUILDINGS AND OTHER STRUCTURES

DRAW 50 DOGS

DRAW 50 FAMOUS STARS

DRAW 50 MONSTERS, CREEPS, SUPERHEROES, DEMONS,
 DRAGONS, NERDS, DIRTS, GHOULS, GIANTS,
 VAMPIRES, ZOMBIES, AND OTHER CURIOSA . . .

DRAW 50 HORSES

DRAW 50 ATHLETES

DRAW 50 CARS, TRUCKS, AND MOTORCYCLES

DRAW 50 CATS

MAKE 25 CRAYON DRAWINGS OF THE CIRCUS

THE DOT, LINE, AND SHAPE CONNECTION

DRAW
50
HOLIDAY
DECORATIONS

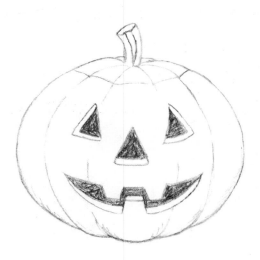

DRAW 50
HOLIDAY
DECORATIONS

LEE J. AMES
WITH RAY BURNS

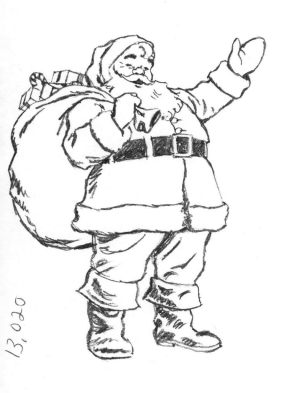

DOUBLEDAY ⚓ NEW YORK

Library of Congress Cataloging in Publication Data

Ames, Lee J.
 Draw 50 holiday decorations.

 Summary: Step-by-step instructions for drawing a
variety of holiday subjects such as Baby New Year, Cupid
and his arrow, July 4th rockets, turkey, pumpkin,
Easter basket, Santa Claus, and a menorah.
 1. Holiday decorations in art—Juvenile literature.
2. Drawing—Technique—Juvenile literature. [1. Drawing
—Technique. 2. Holidays in art] I. Burns, Raymond,
1924– II. Title. III. Title: Draw fifty holiday
decorations.
NC825.H65A44 1987 743′.87455941 87-15581
ISBN 0-385-19057-3
ISBN 0-385-19058-1 (lib.bdg.)

To Ray Burns for a job well done

To the Reader

Holiday times are special times because they inspire us to be creative—to make things that will delight family and friends alike. Here is a book to help celebrate those special times. It will show you how to draw a variety of holiday subjects—a jack-o'-lantern for Halloween, a bunny for Easter, Santa Claus for Christmas, a menorah for Hanukkah, and much more. With these drawings, you can then decorate greeting cards, gift tags, place cards, party favors, and anything else you can think of. Or you may just want to draw the pictures for the fun of it.

At first glance, these drawings may appear difficult. But if you take your time and carefully follow the step-by-step instructions in each illustration, you will be able to produce a very satisfying finished drawing.

To begin, you will need only clean paper, a pencil with moderately soft lead (HB or No. 2), and a kneaded eraser (available at art supply stores). Select the illustration you want to draw, and then, *very lightly and carefully,* sketch out step number one. Then, also very *lightly and carefully,* add step number two to step number one. These steps, which may look the easiest, are the most important. A mistake here can ruin your entire drawing at the end. And remember to watch not only the lines themselves, but the *spaces between the lines* to make sure that they are the same as the drawing in the book. As you sketch out these first steps, it might be a good idea to hold your work up to a mirror. Sometimes the mirror shows that you've twisted the drawing off to one side without being aware of it.

In each drawing, the new step is shown darker than the previous one so that it can be clearly seen. But you should keep your own work very light. Here's where the kneaded eraser will come in handy; use it to lighten your work after each step.

When you have finished your picture, you may want to go over it with some India ink. Apply this with a fine brush or pen. When the ink has thoroughly dried, erase the entire drawing with the kneaded eraser. The erasing will not affect the India ink.

The most important thing to remember is that even if your first attempts are not as good as you would like them to be, you should not get discouraged. Like any other talent, whether it be performing gymnastic feats or playing the piano, drawing takes practice to do your best.

Though there are many ways to learn how to draw, the step-by-step method used in this book should start you off in the right direction.

LEE J. AMES

To the Parent or Teacher

"Leslie can draw a Halloween pumpkin better than anybody else!" Such peer acclaim and encouragement generate incentive. Contemporary methods of art instruction (freedom of expression, experimentation, self-evaluation of competence and growth) provide a vigorous, fresh-air approach for which we must all be grateful.

New ideas need not, however, totally exclude the old. One such is the "follow me, step-by-step" approach. In my young learning days this method was so common, and frequently so exclusive, that the student became nothing more than a pantographic extension of the teacher. In those days it was excessively overworked.

This does not mean that the young hand is never to be guided. Rather, specific guiding is fundamental. Step-by-step guiding that produces satisfactory results is valuable even when the means of accomplishment are not fully understood by the student.

The novice with a musical instrument is frequently taught to play simple melodies as quickly as possible, well before he learns the most elemental scratchings at the surface of music theory. The resultant self-satisfaction, pride in accomplishment, can be a significant means of providing motivation. And all from mimicking an instructor's "Do-as-I-do"

Mimicry is prerequisite for developing creativity. We learn the use of our tools by mimicry. Then we can use those tools for creativity. To this end I would offer the budding artist the opportunity to memorize or mimic (rote-like, if you wish) the making of "pictures." "Pictures" he has been anxious to be able to draw.

The use of this book should be available to anyone who *wants* to try another way of flapping his wings. Perhaps he or she will then get off the ground when a friend says, "Leslie can draw a Halloween pumpkin better than anybody else!"

LEE J. AMES

DRAW 50 HOLIDAY DECORATIONS

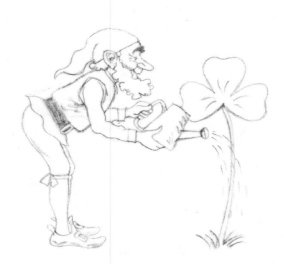

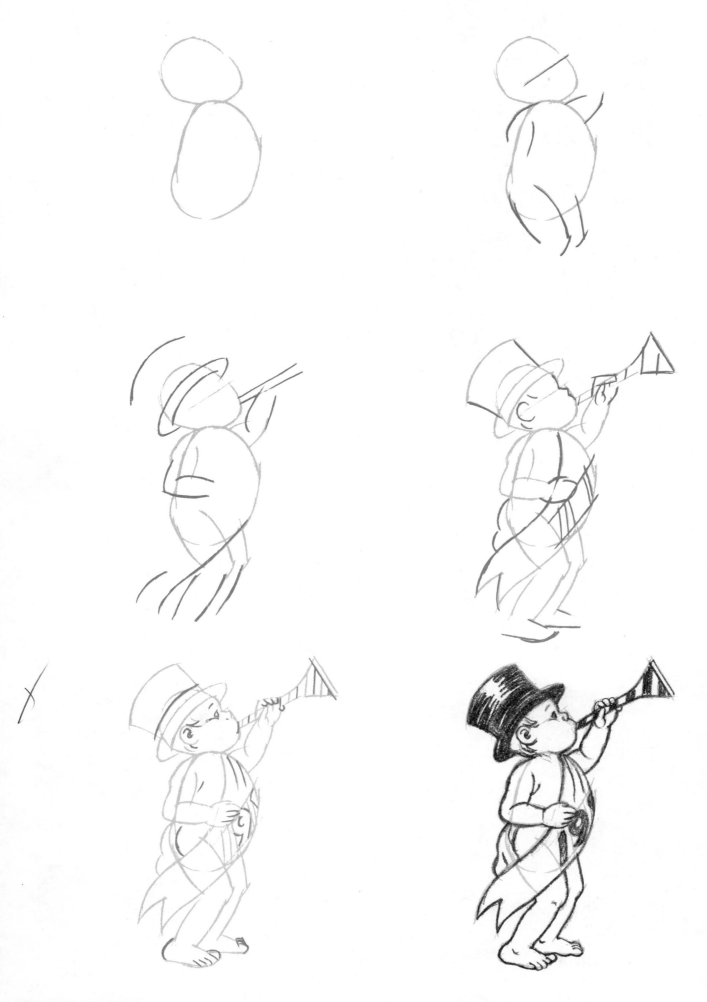

New Year's Day

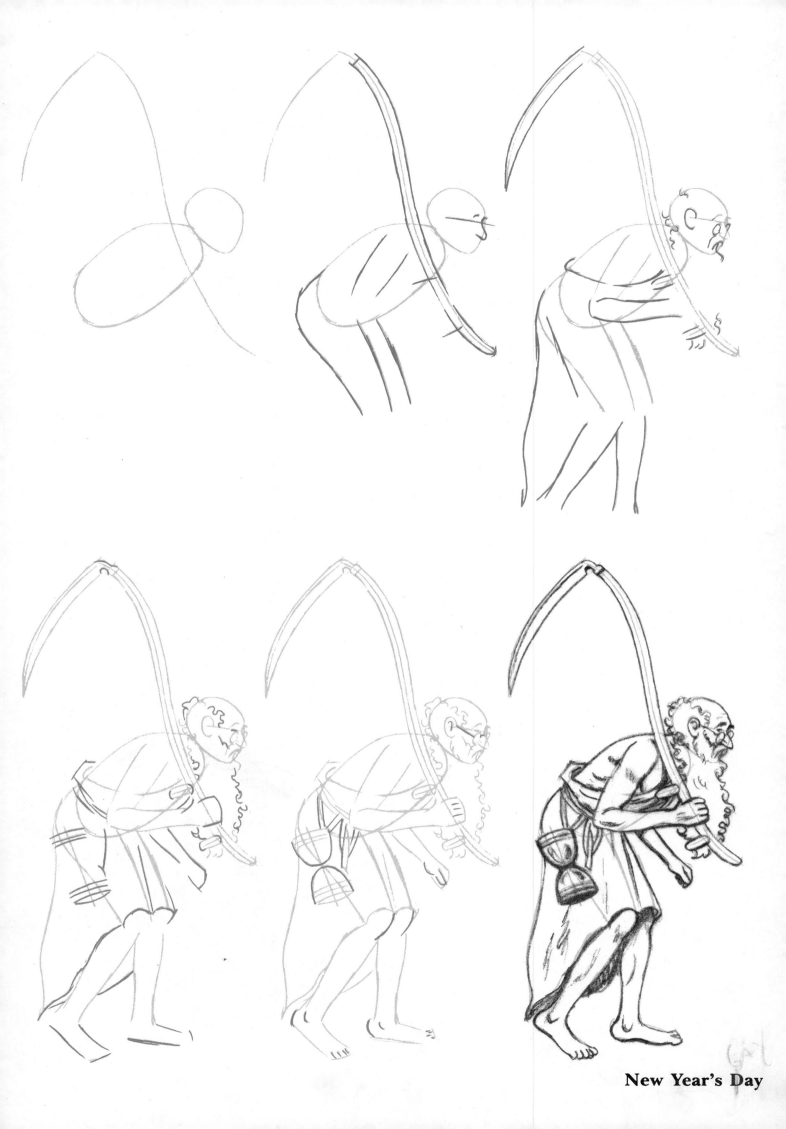

New Year's Day

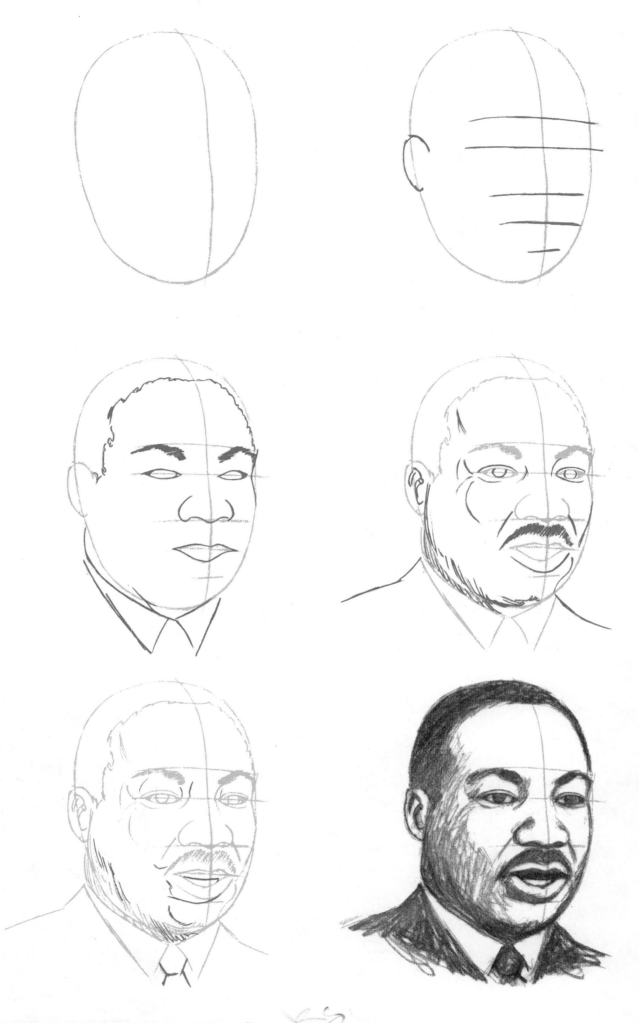

Martin Luther King, Jr.'s Birthday

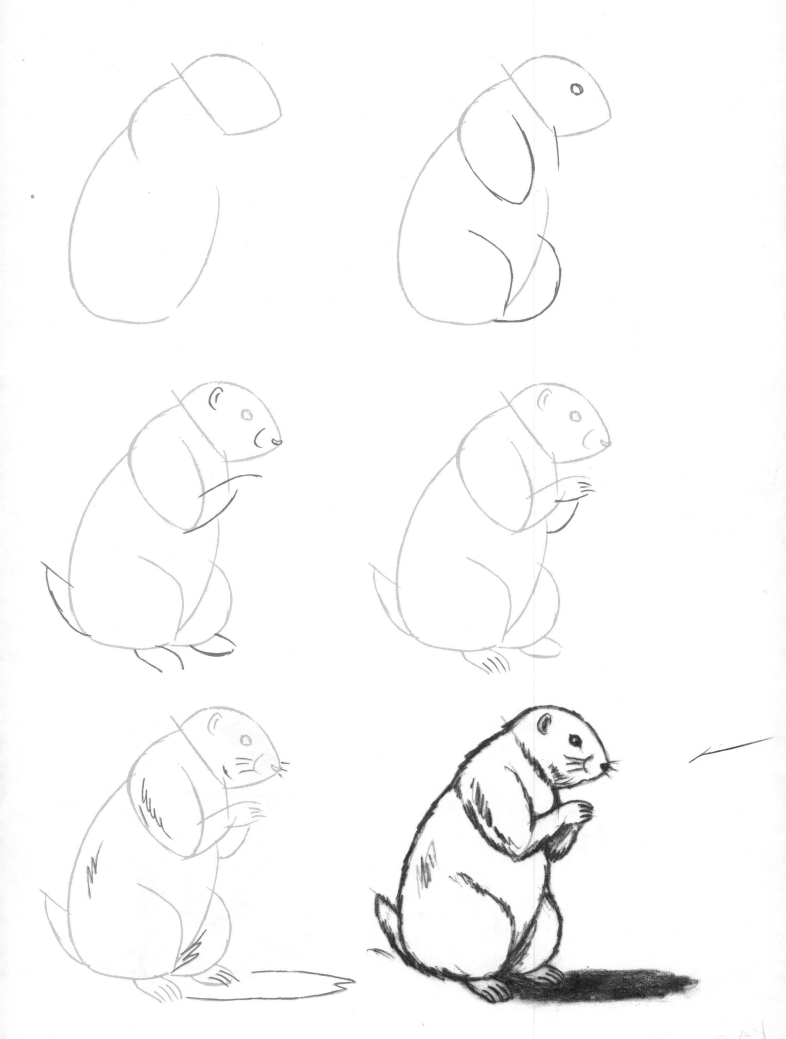

Groundhog Day

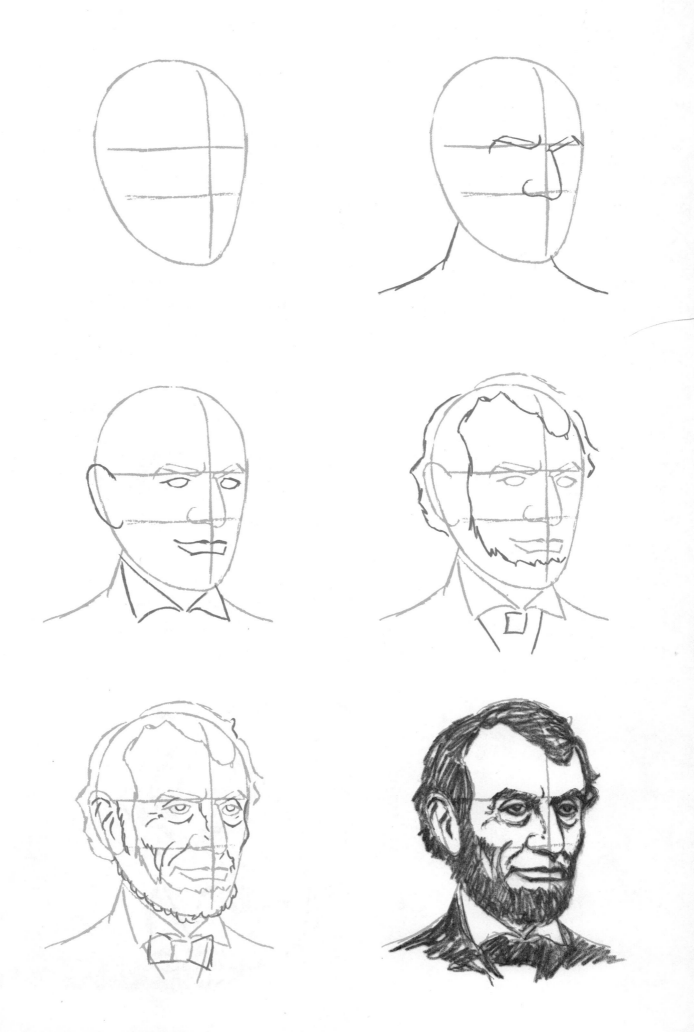

Abraham Lincoln's Birthday

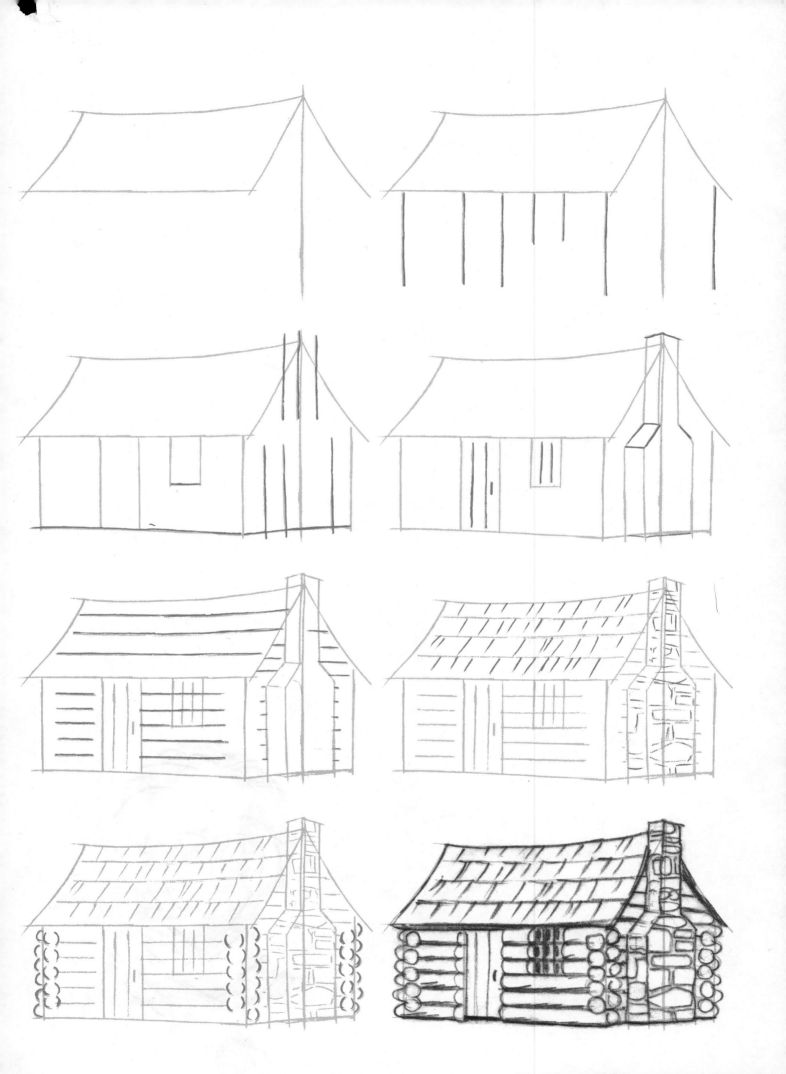

Abraham Lincoln's Birthday

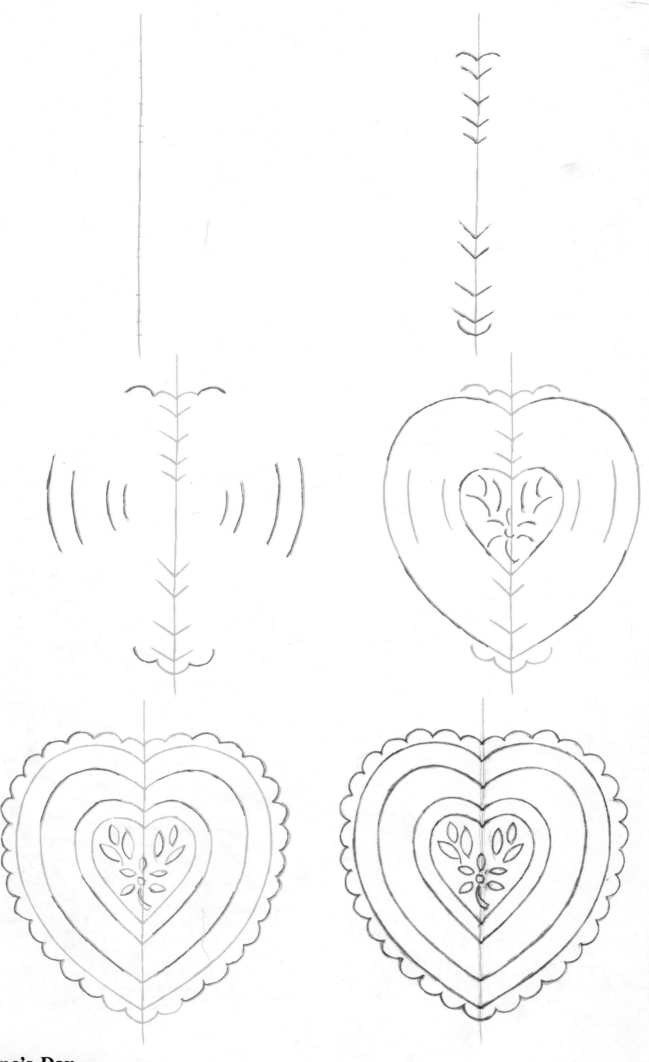

Valentine's Day

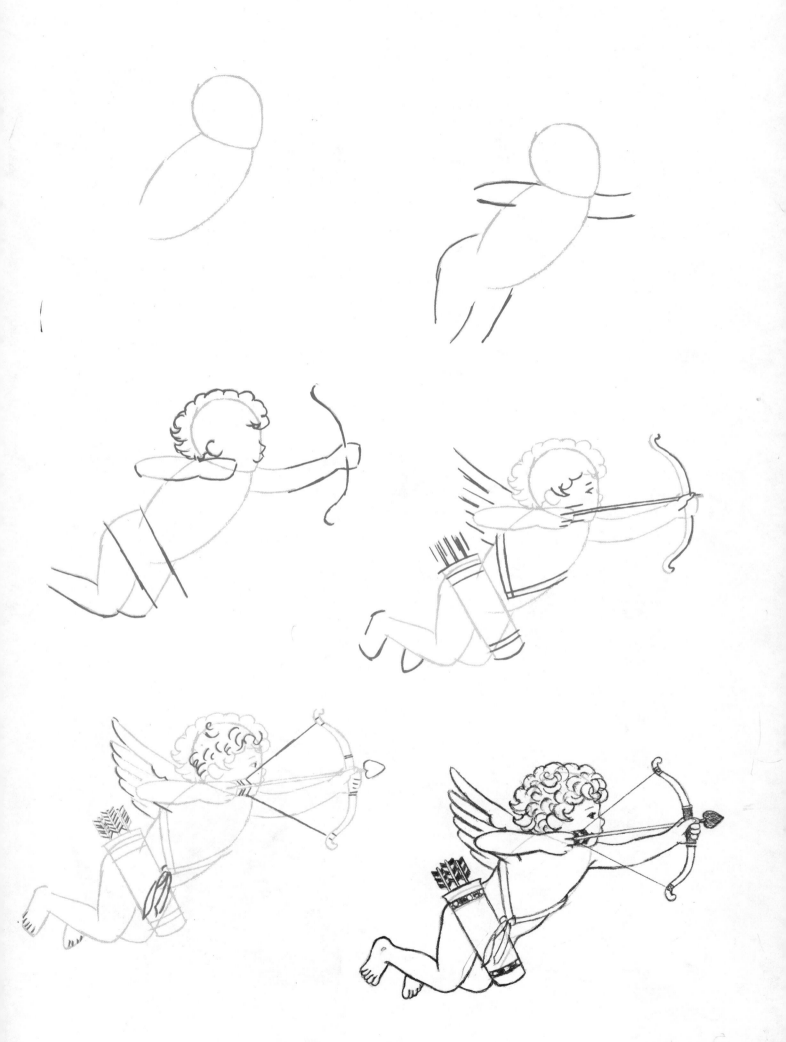

Valentine's Day

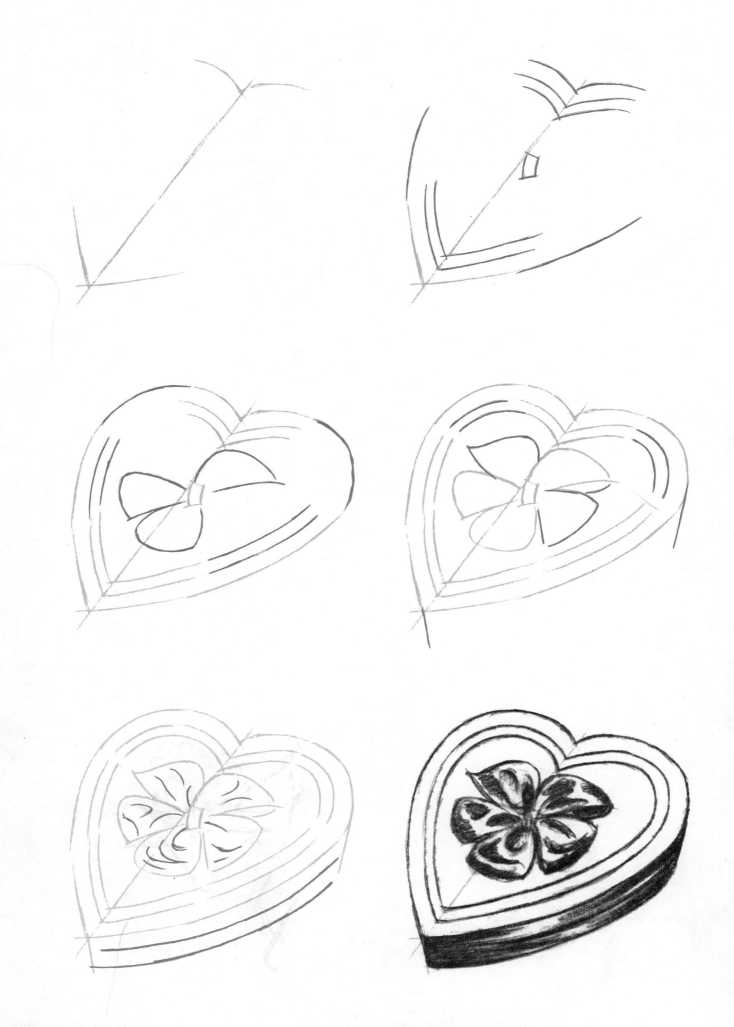

Valentine's Day

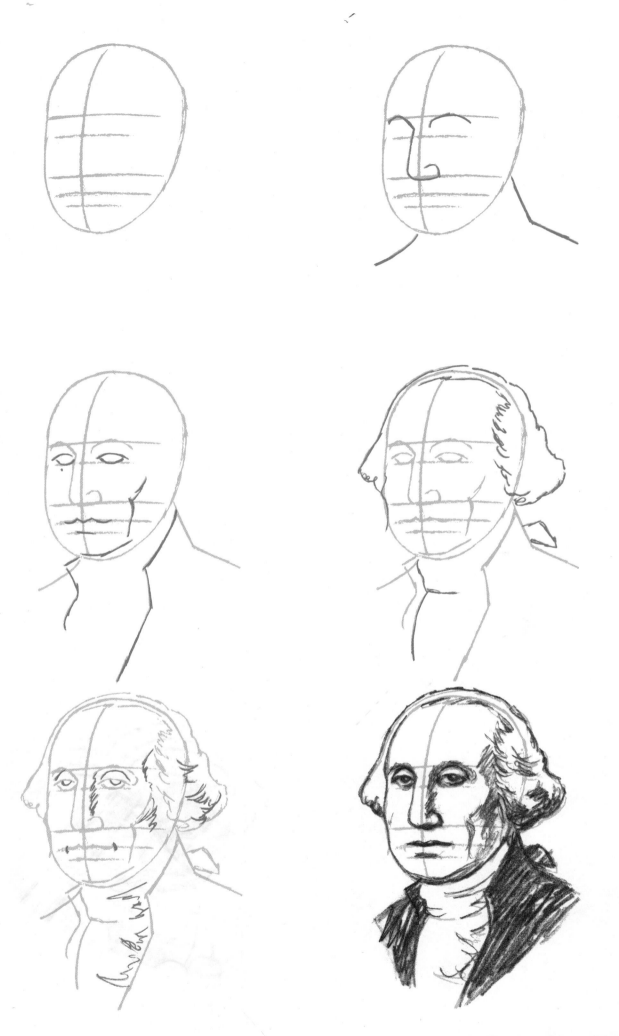

George Washington's Birthday

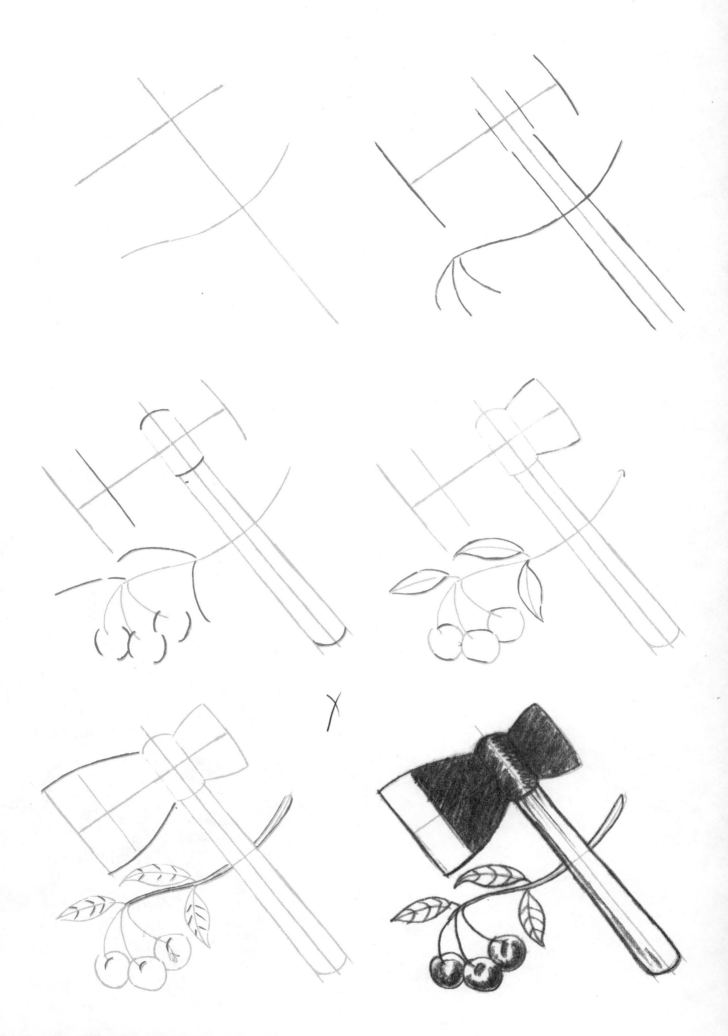

George Washington's Birthday

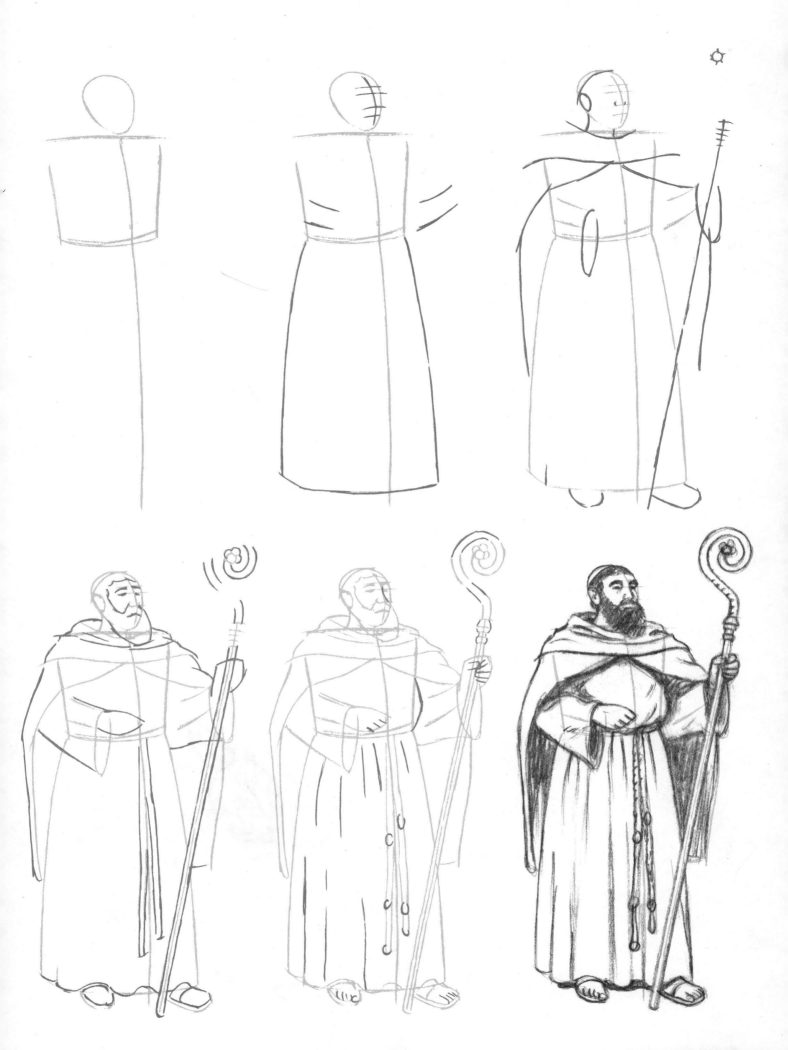

St. Patrick's Day

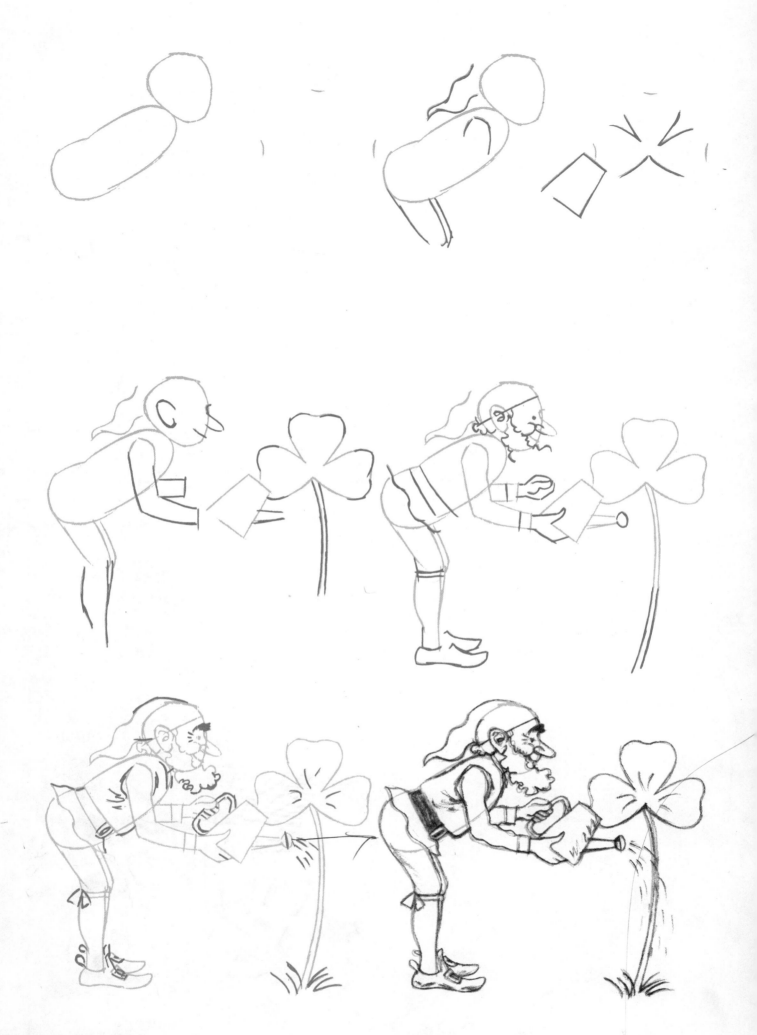

St. Patrick's Day

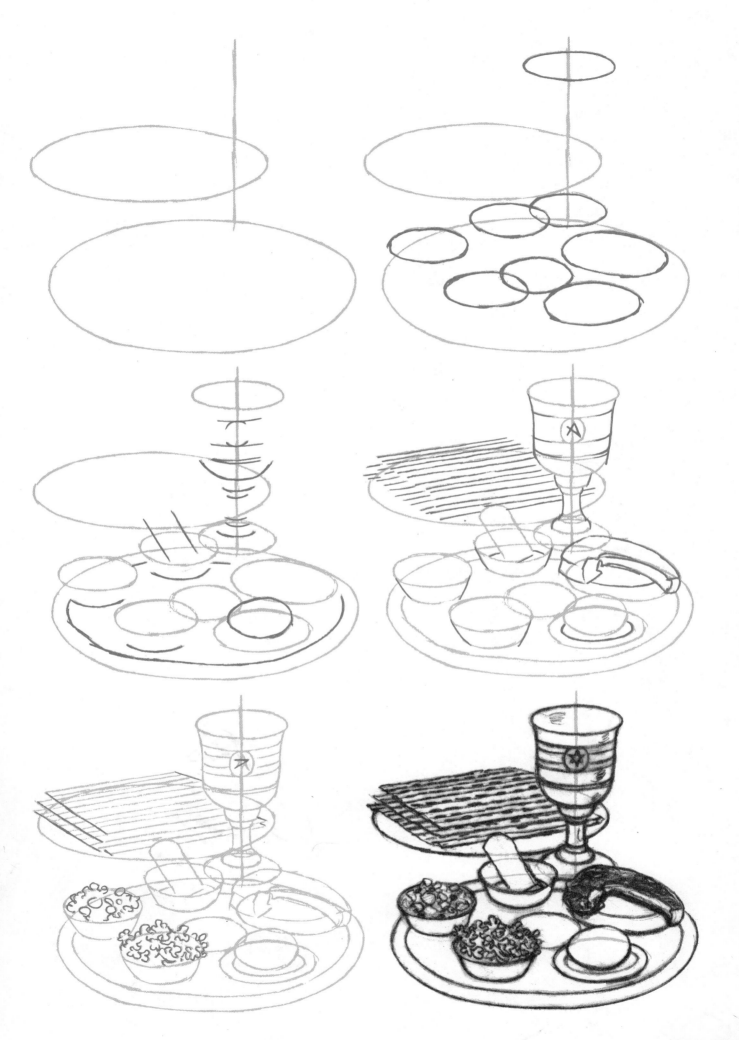

Passover

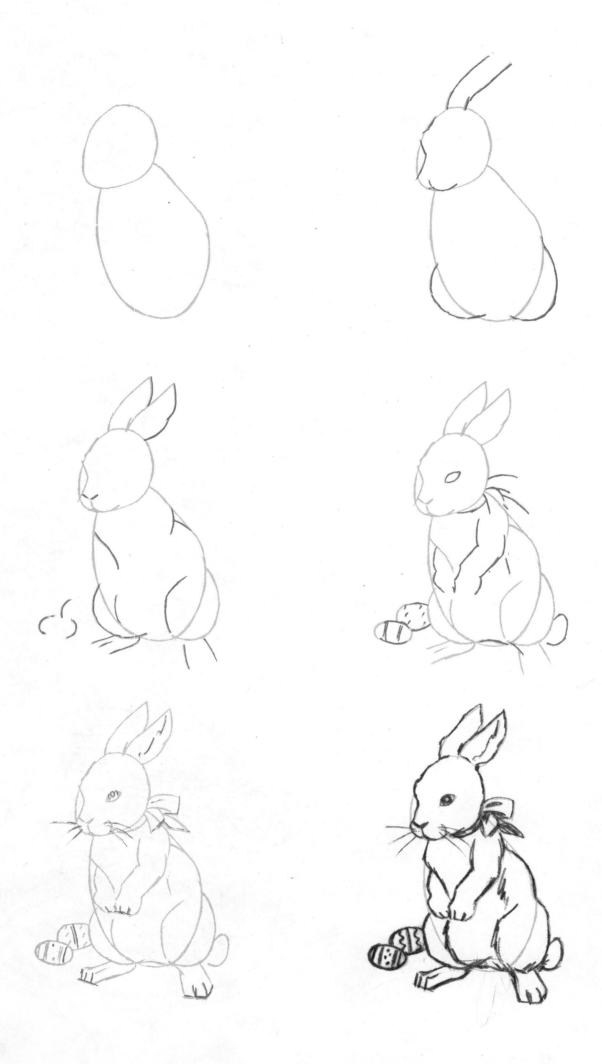

Easter

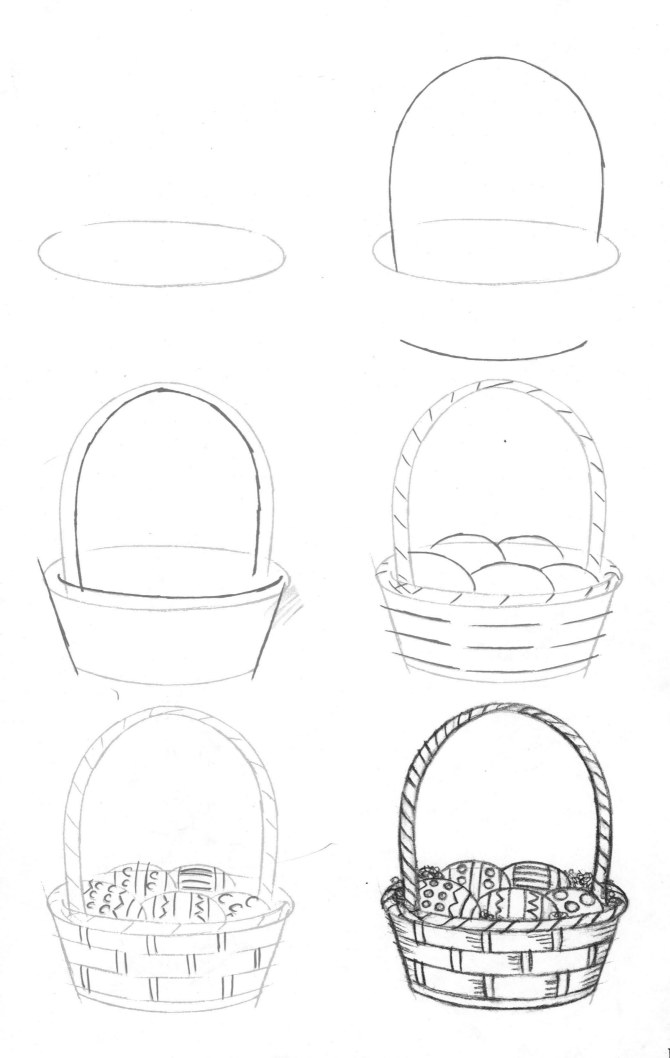

Easter

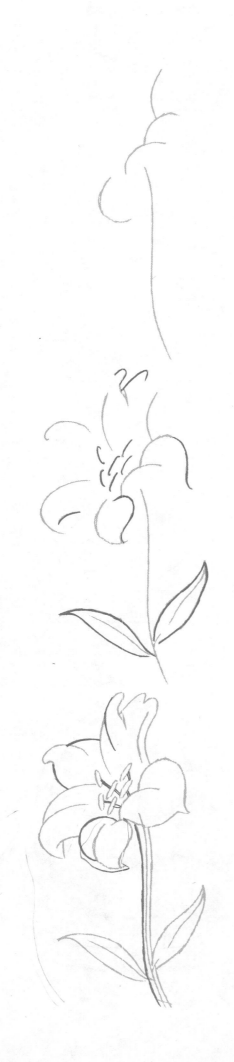
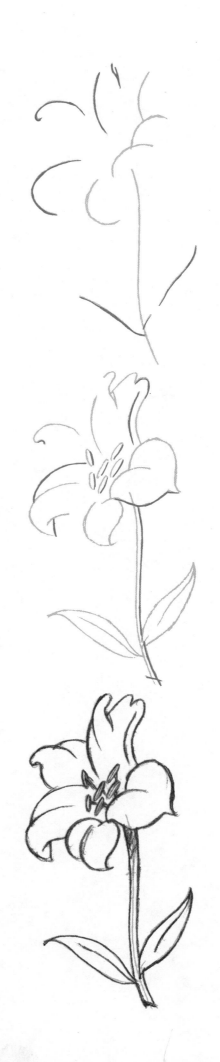

Easter

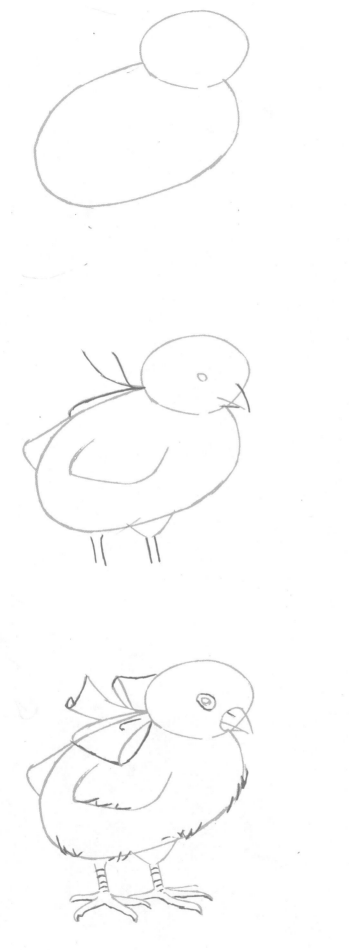
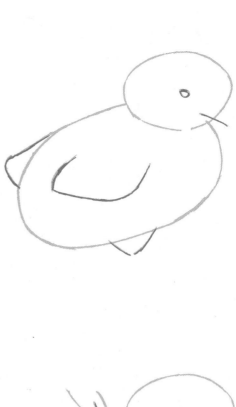
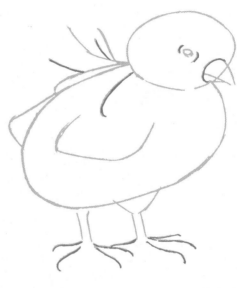
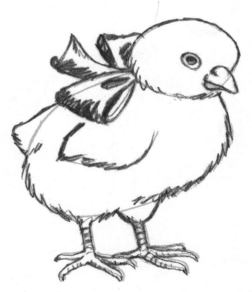

Easter

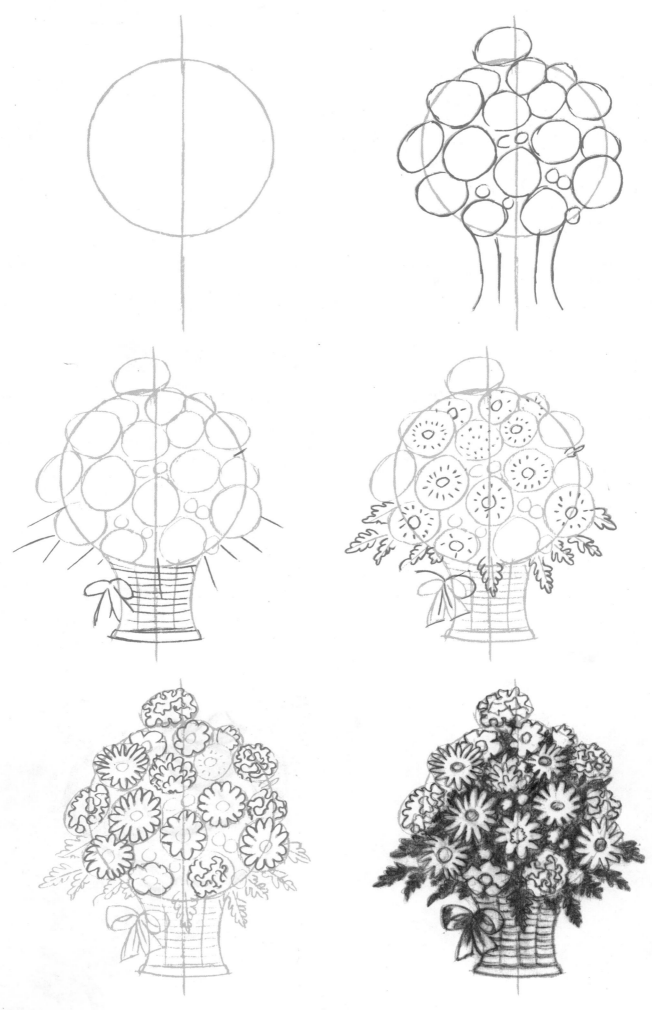

Mother's Day

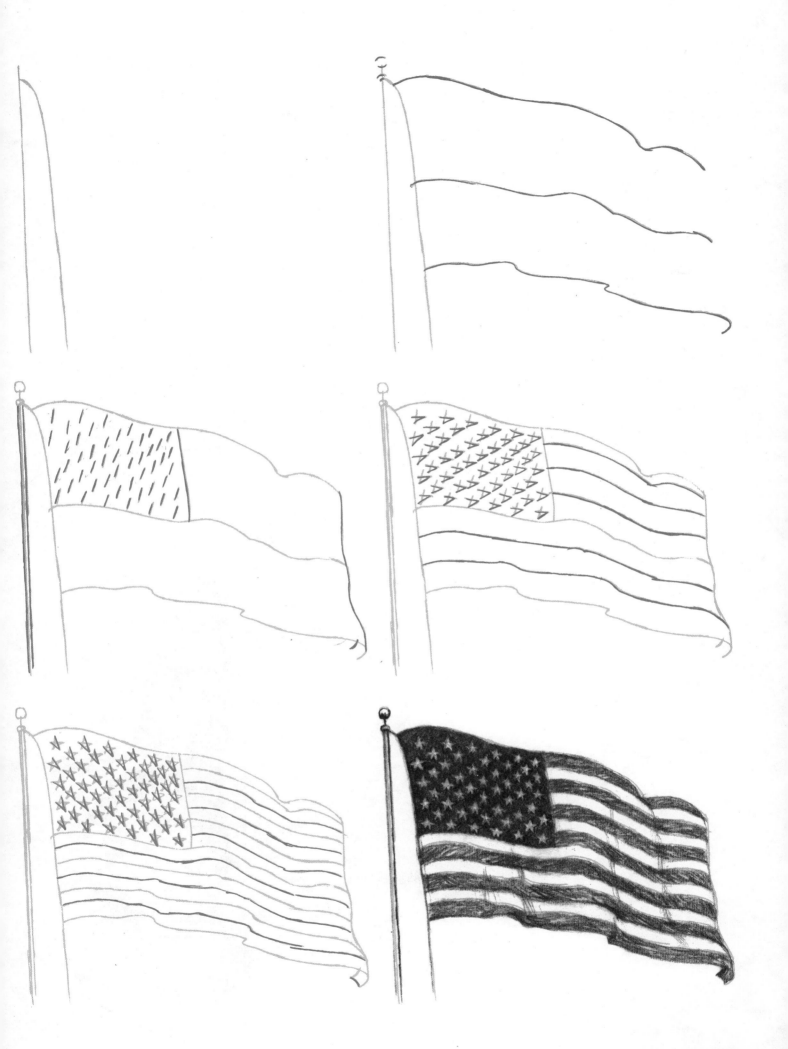

Flag Day

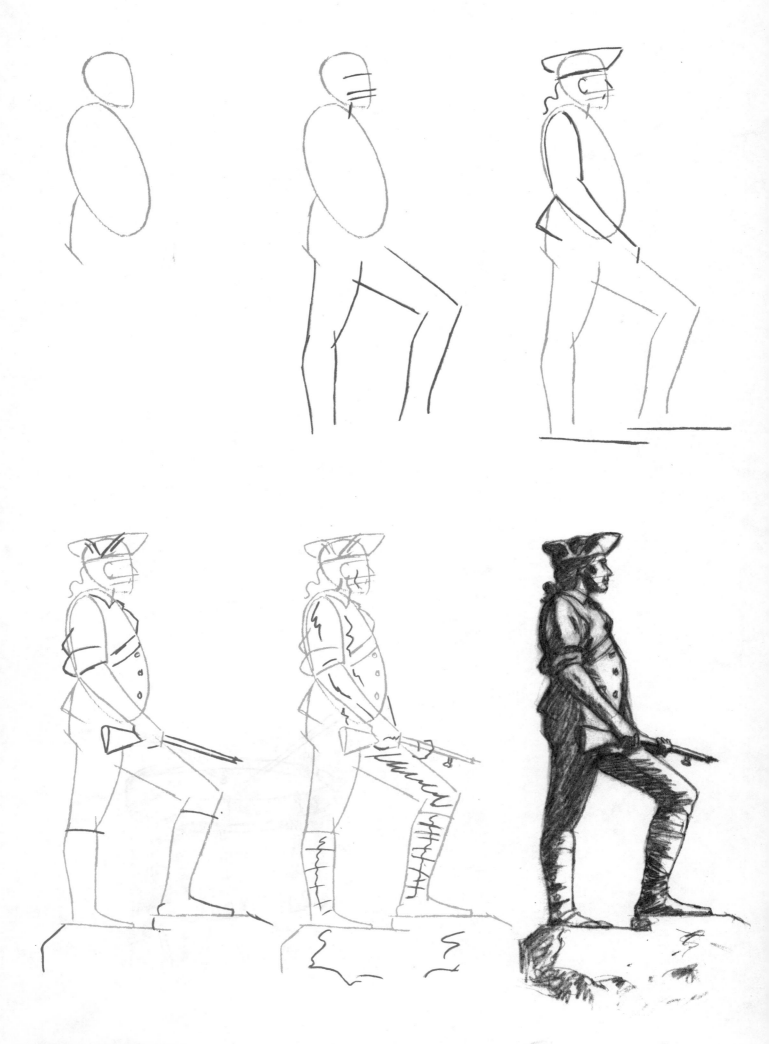

Independence Day

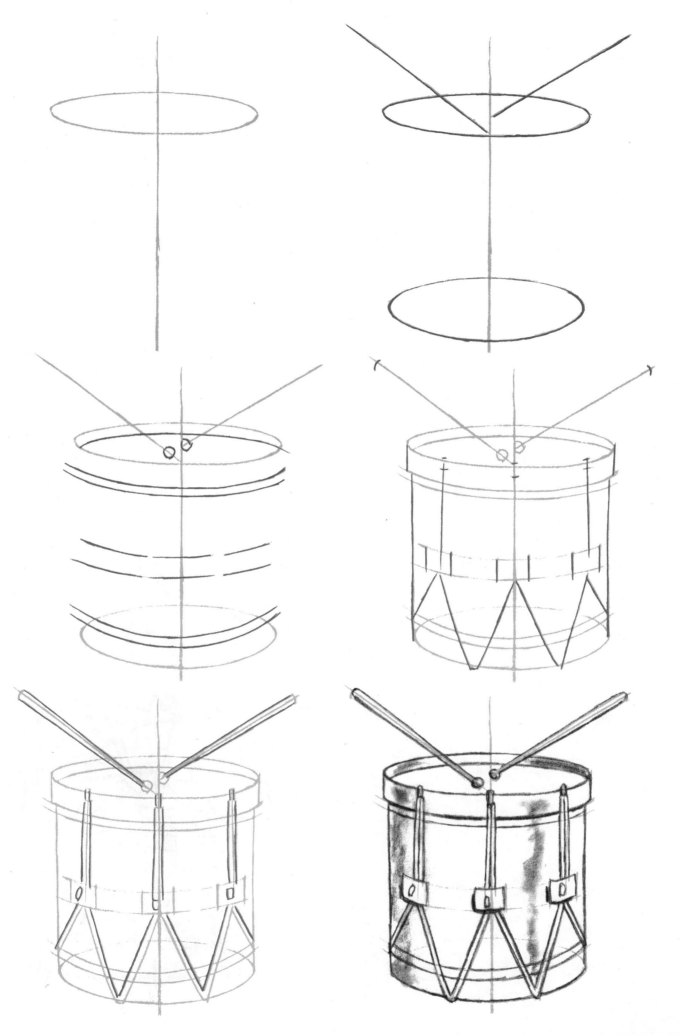

Independence Day

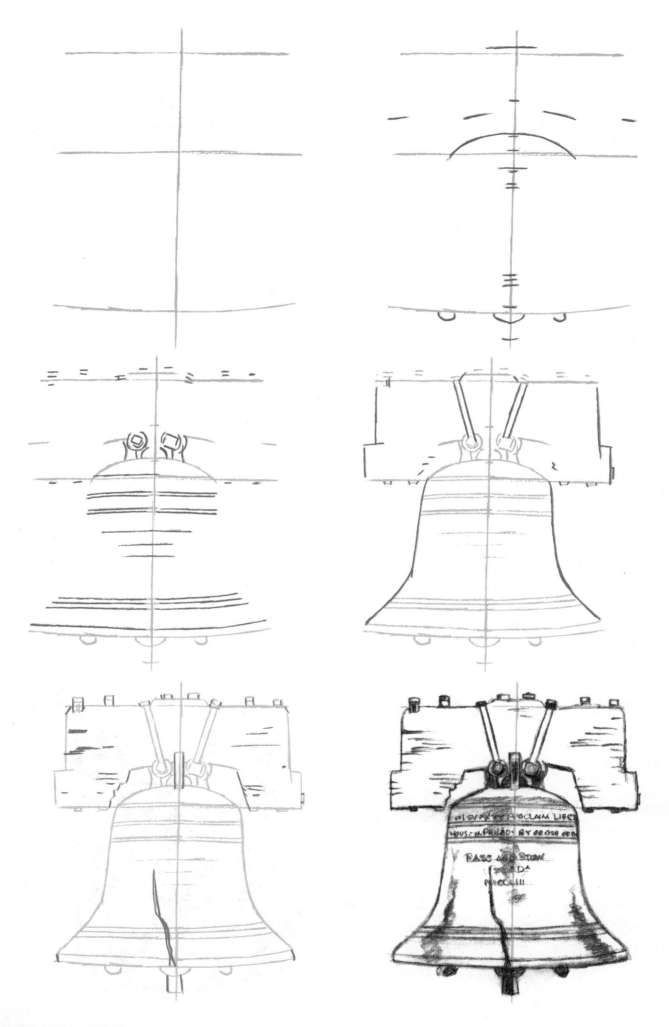

Independence Day

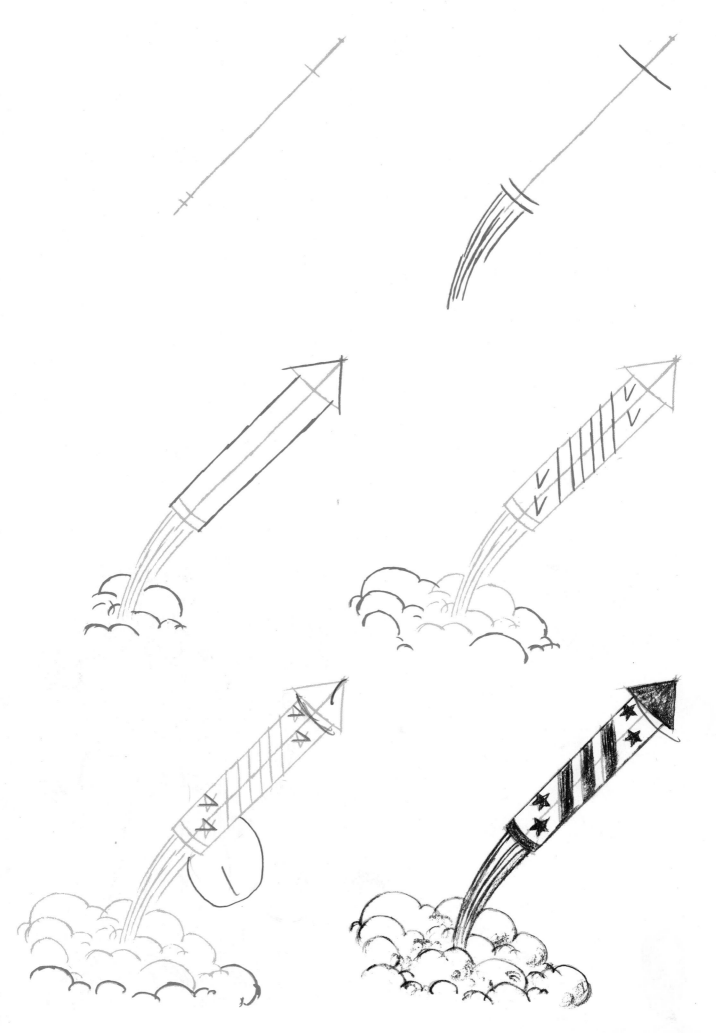

Independence Day

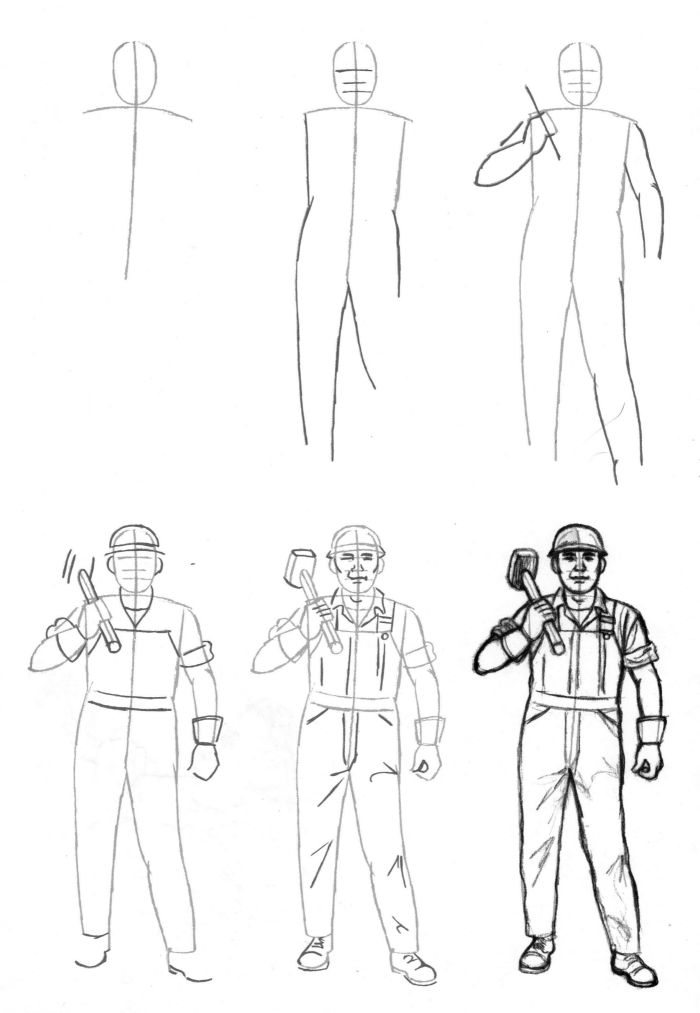

Labor Day

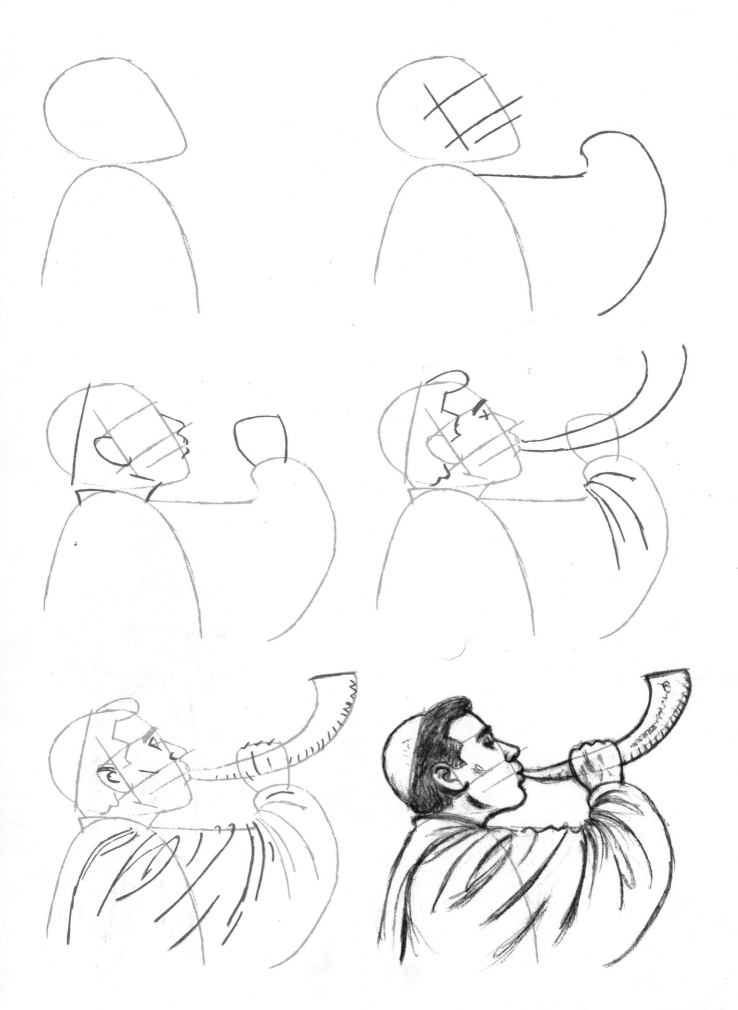

Yom Kippur/Rosh Hashanah

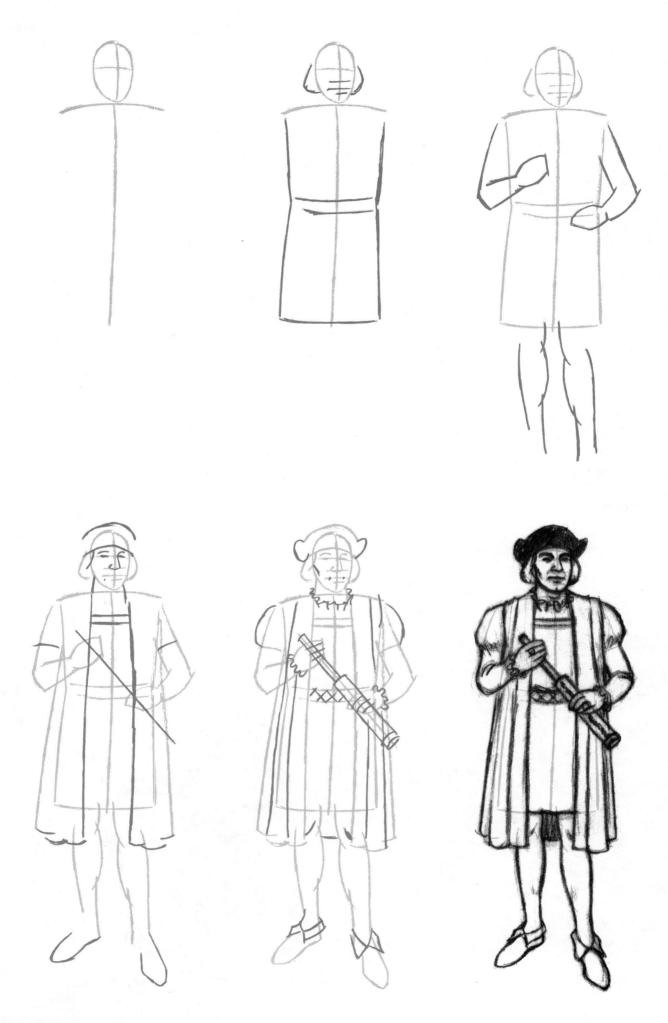

Columbus Day

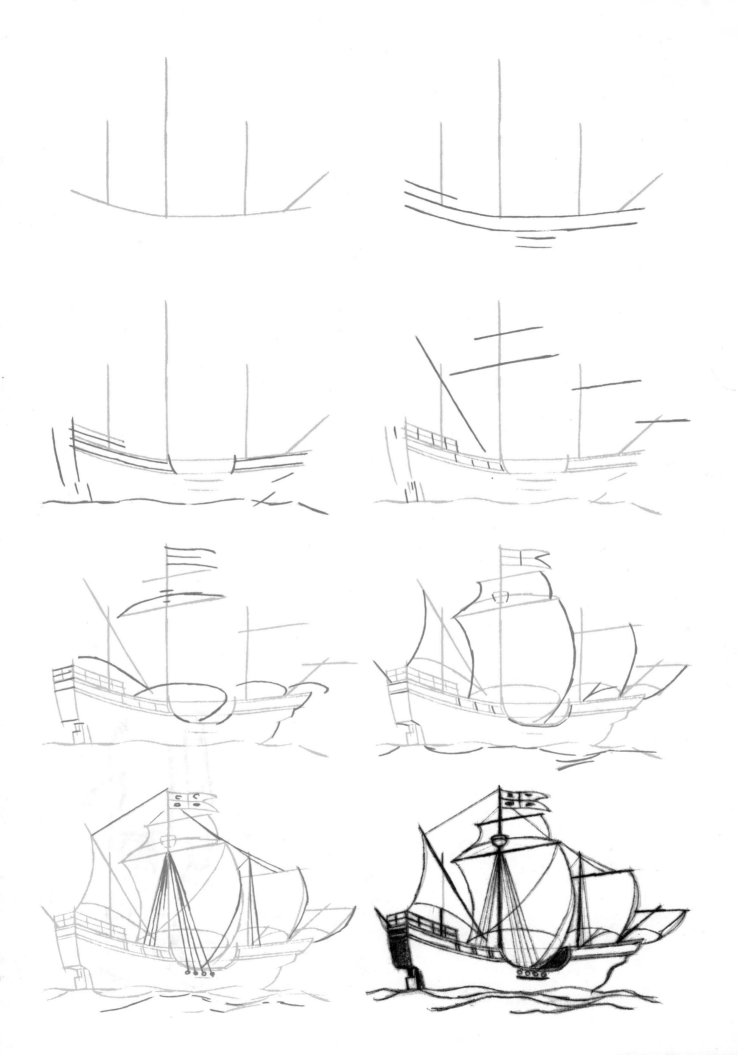

Columbus Day

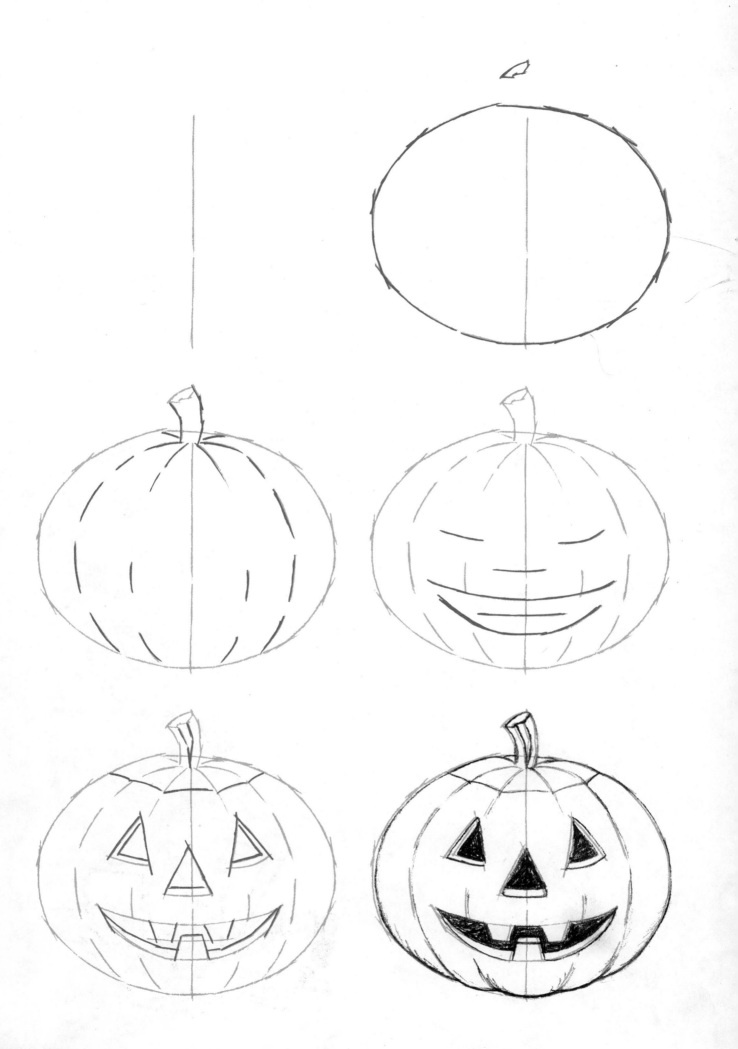

Halloween

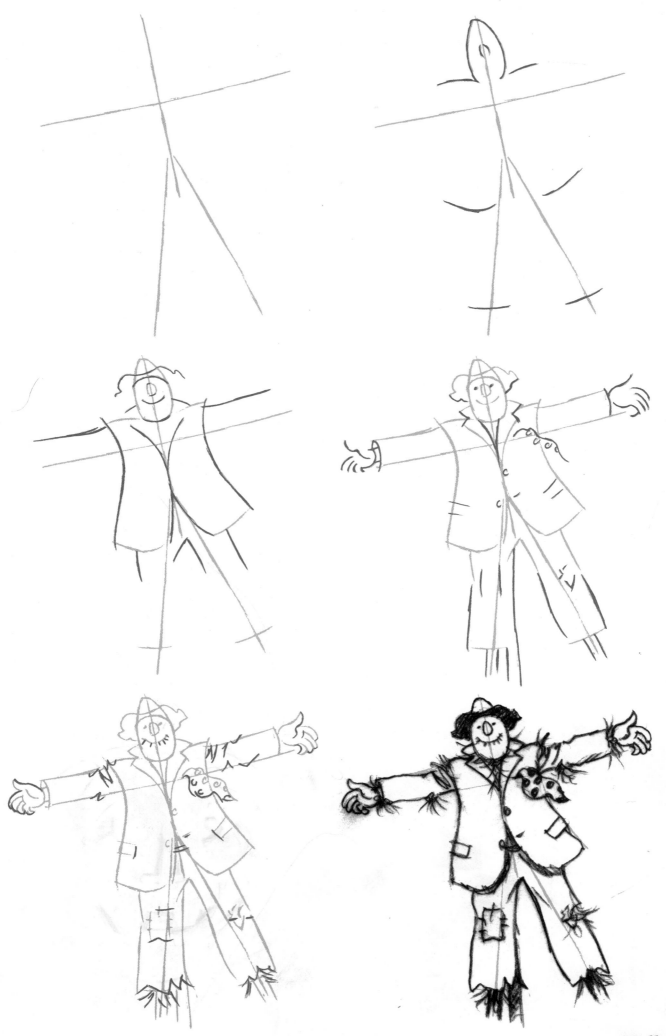

Halloween

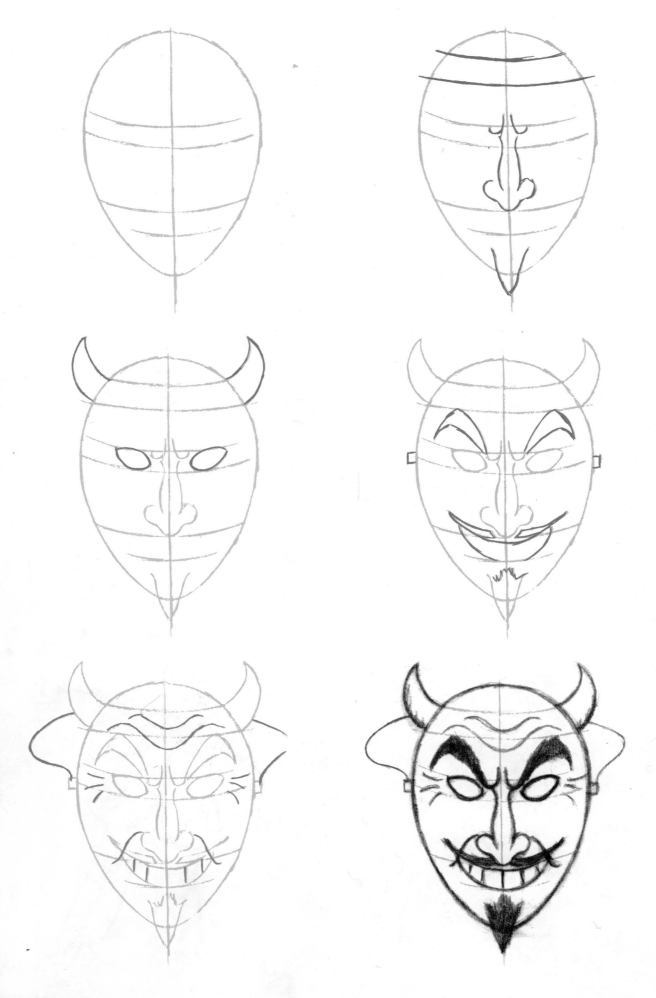

Halloween

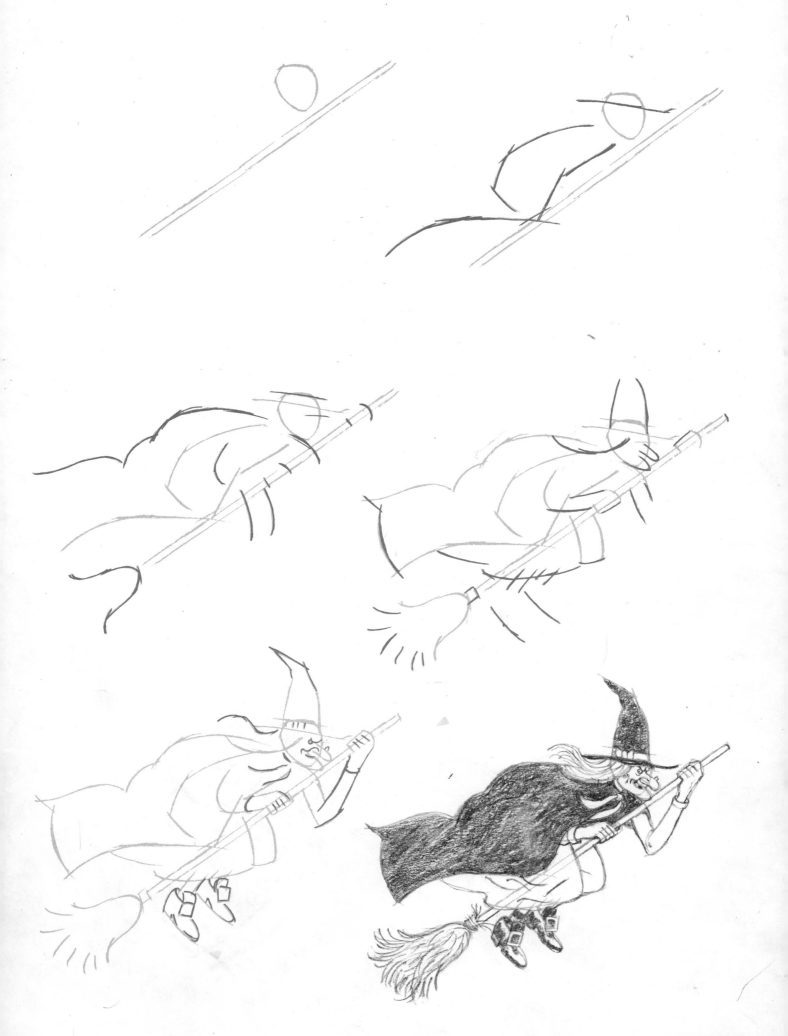

Halloween

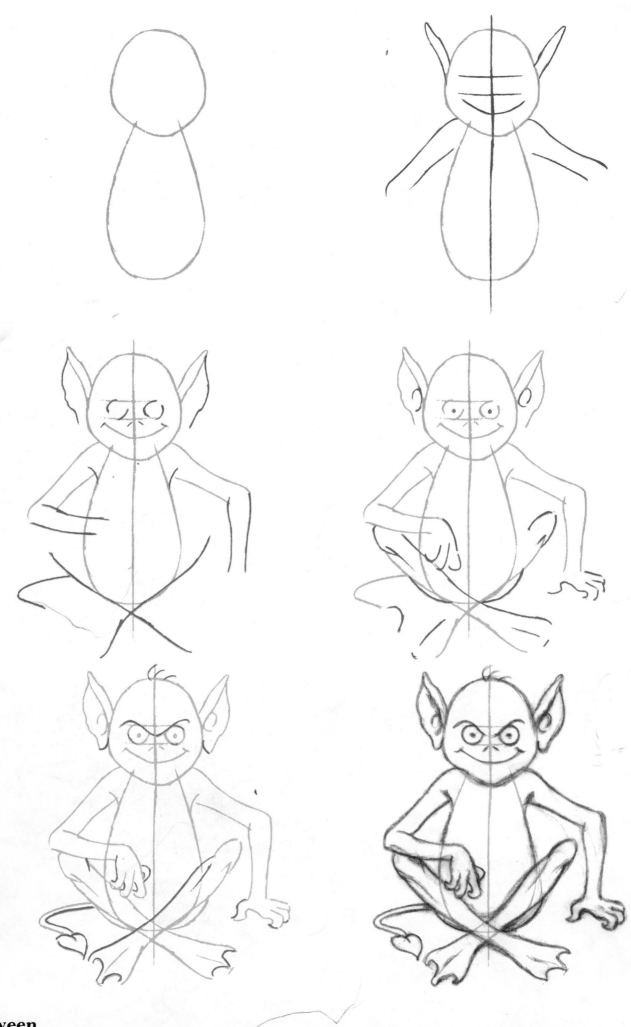

Halloween

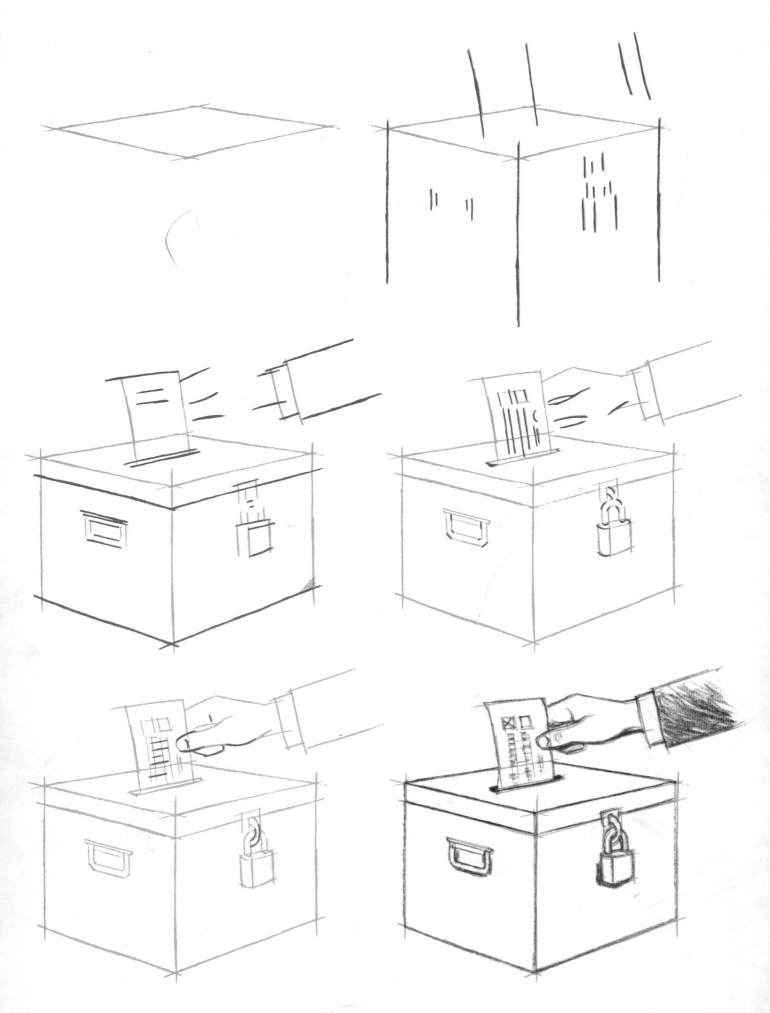

Election Day

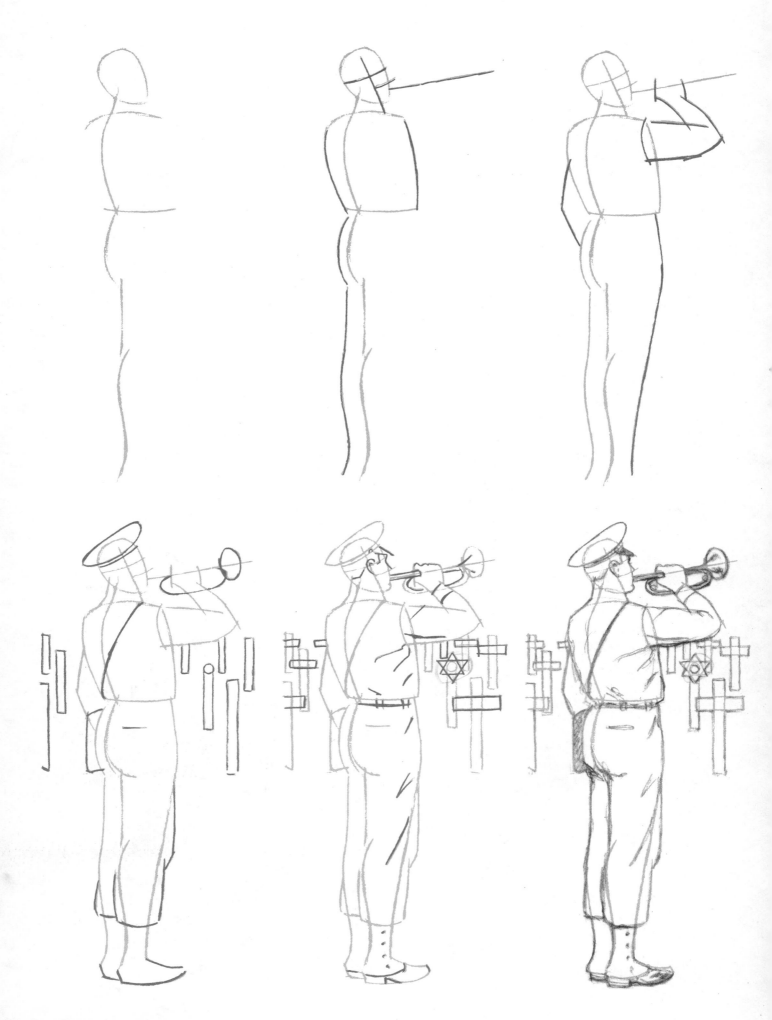

Veterans Day

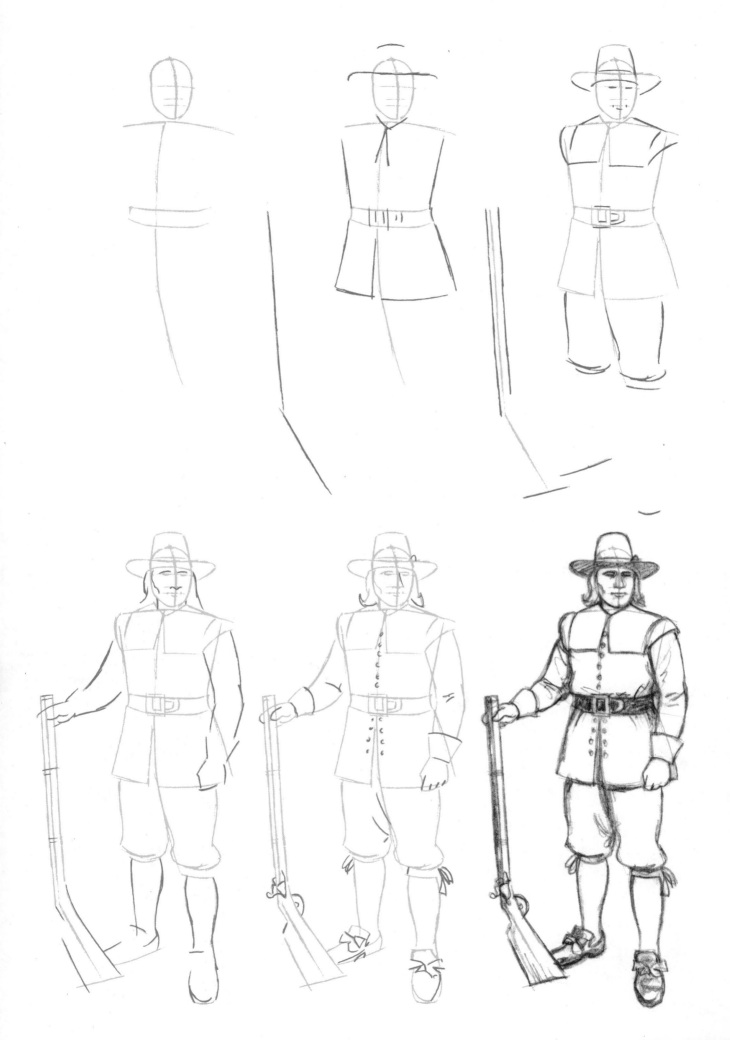

Thanksgiving

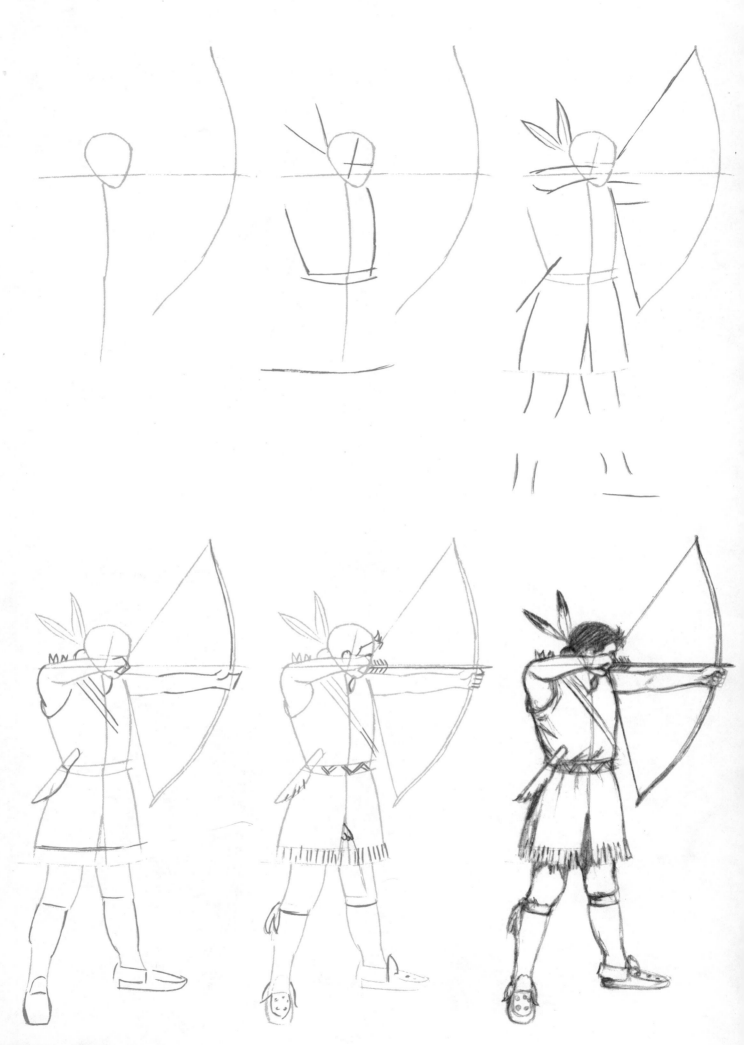

Thanksgiving

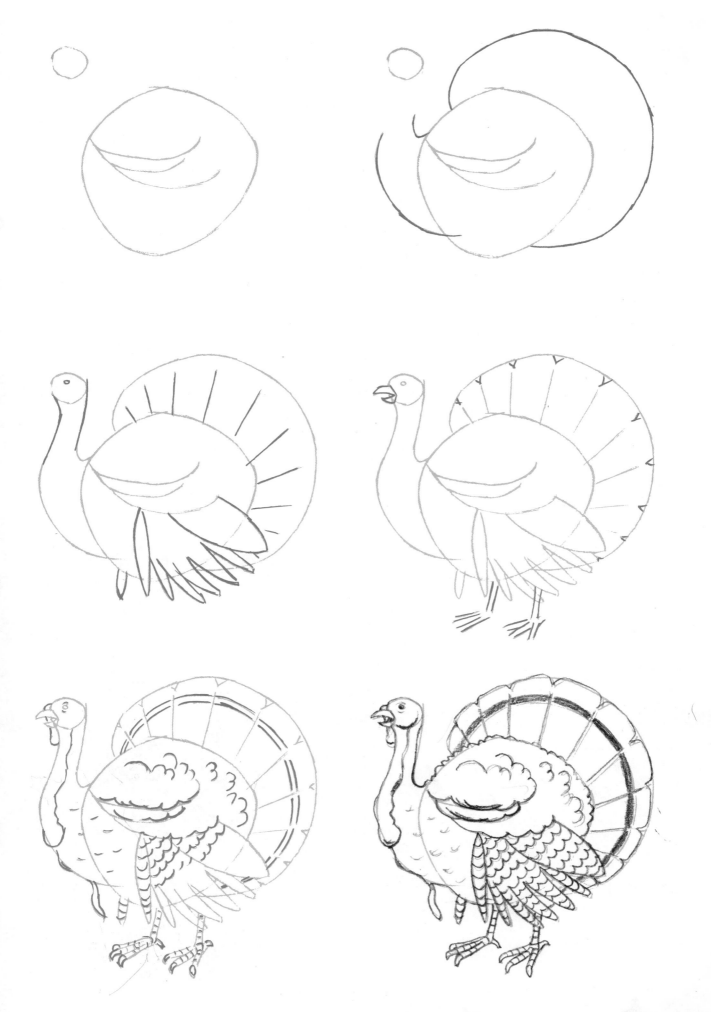

Thanksgiving

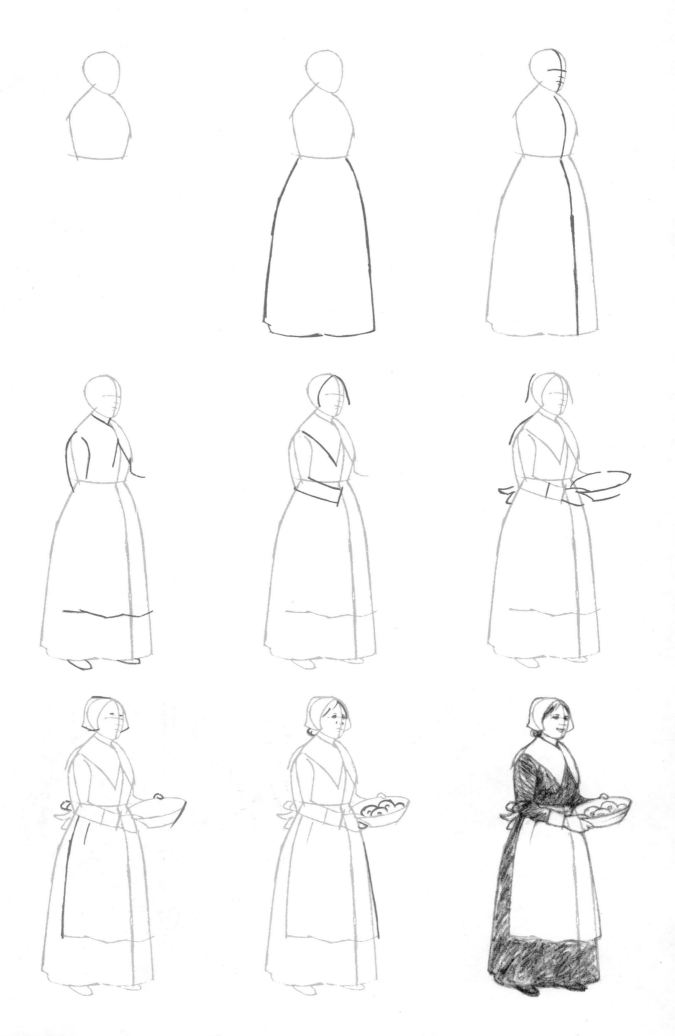

Thanksgiving

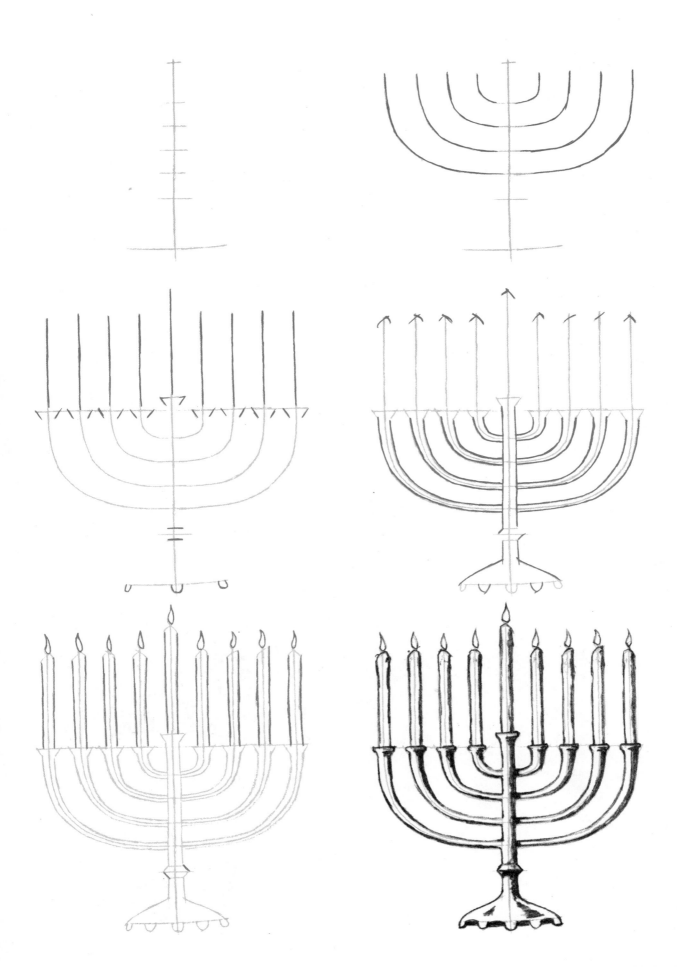

Hanukkah

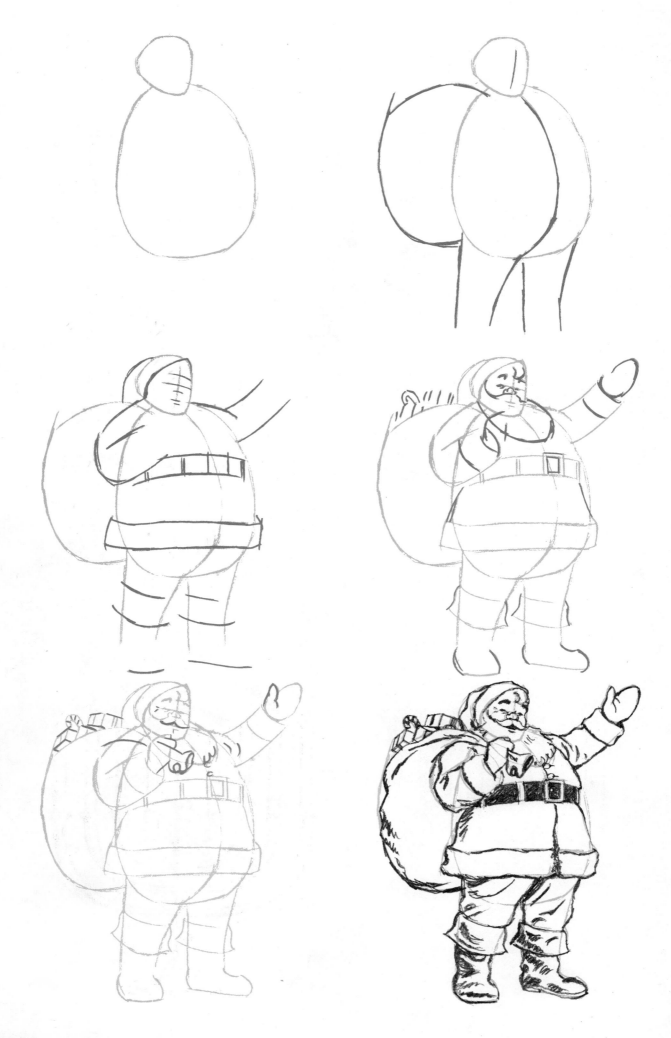

Christmas

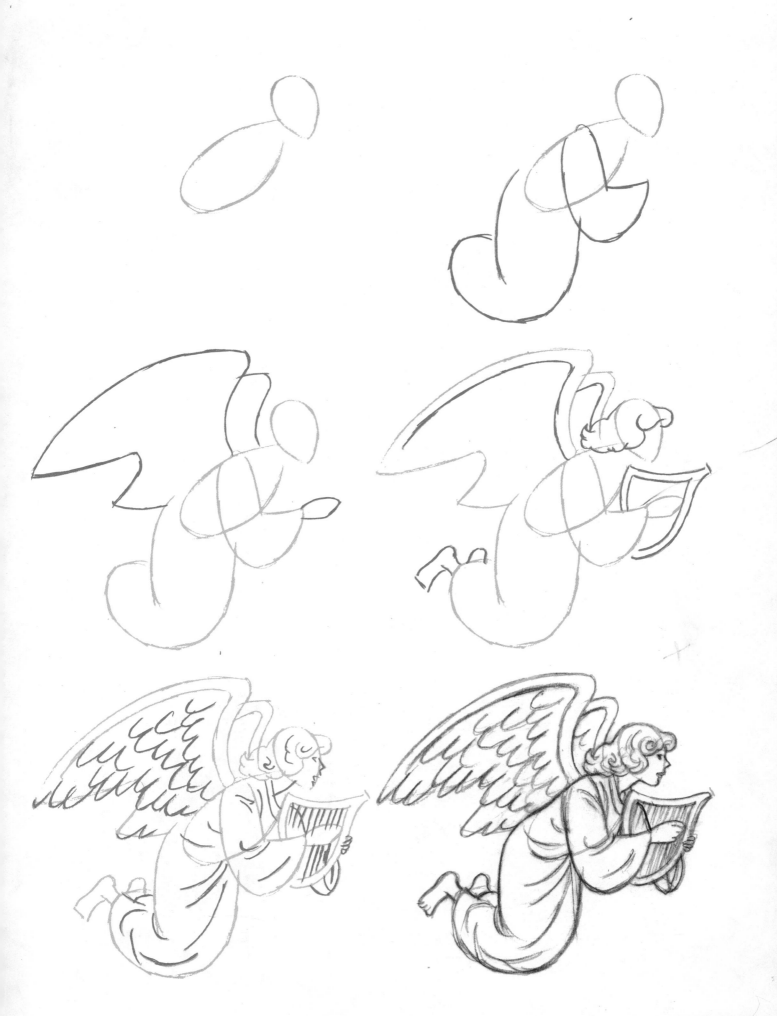

Christmas

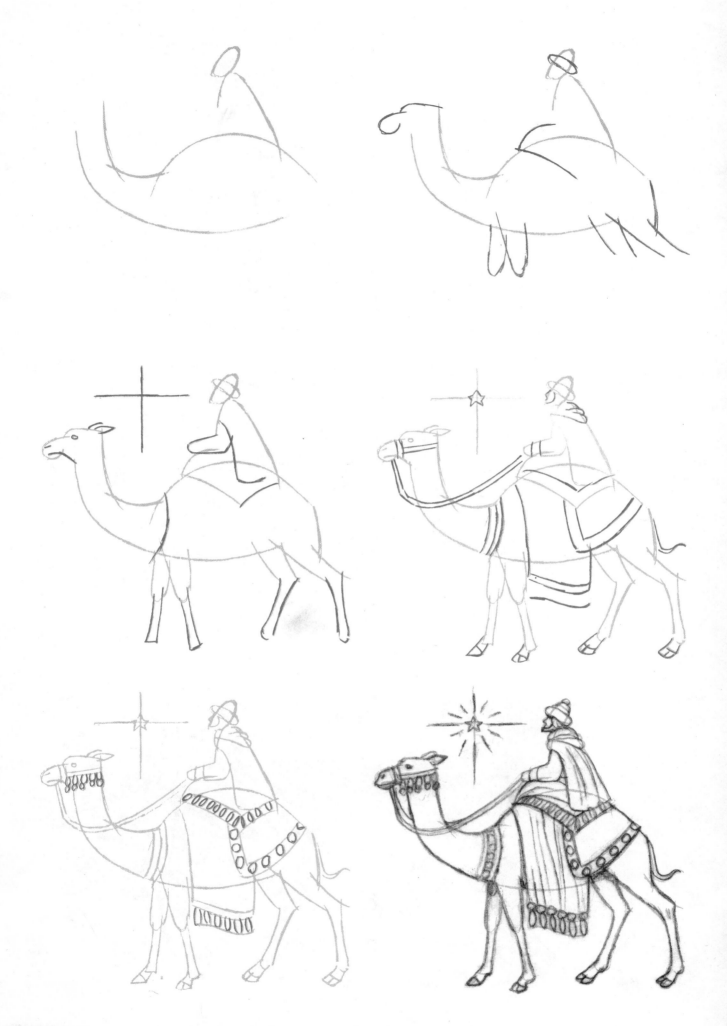

Christmas

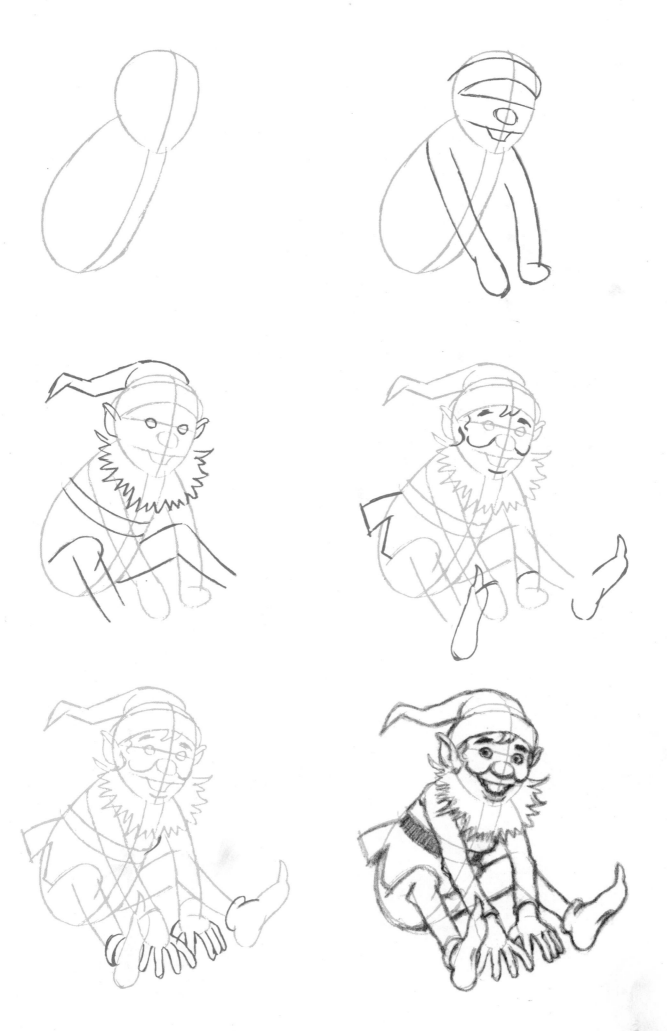

Christmas

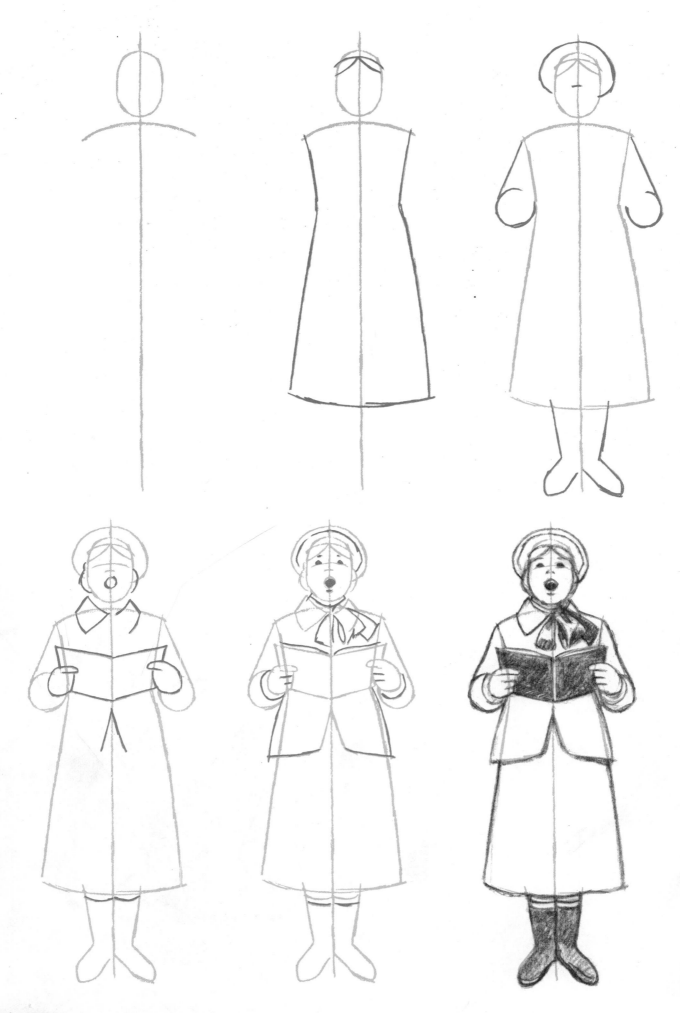

Christmas

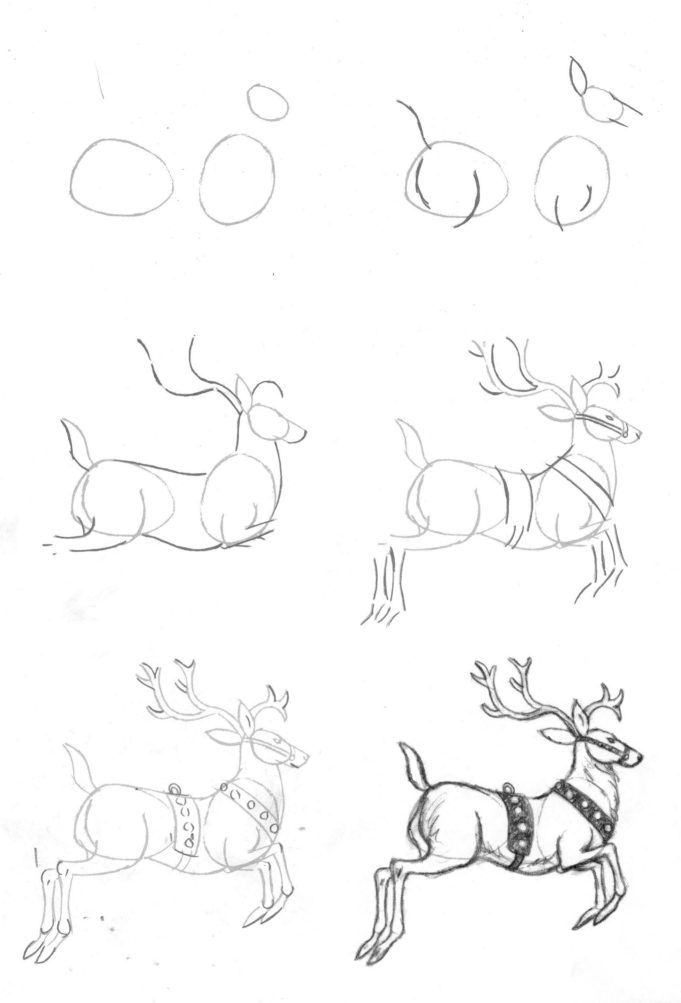

Christmas

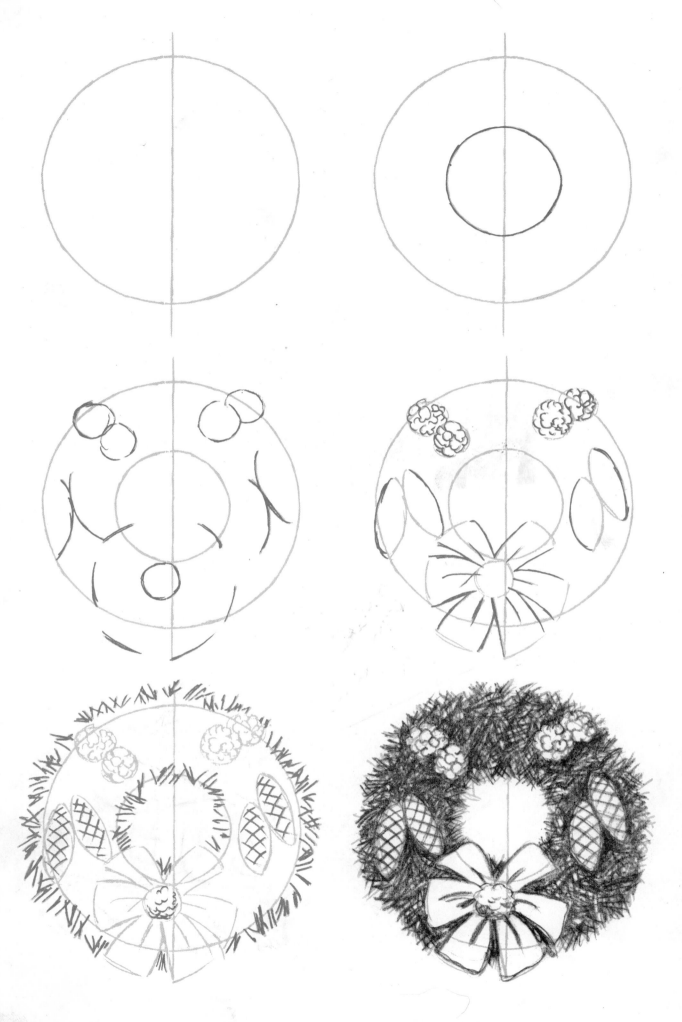

Christmas

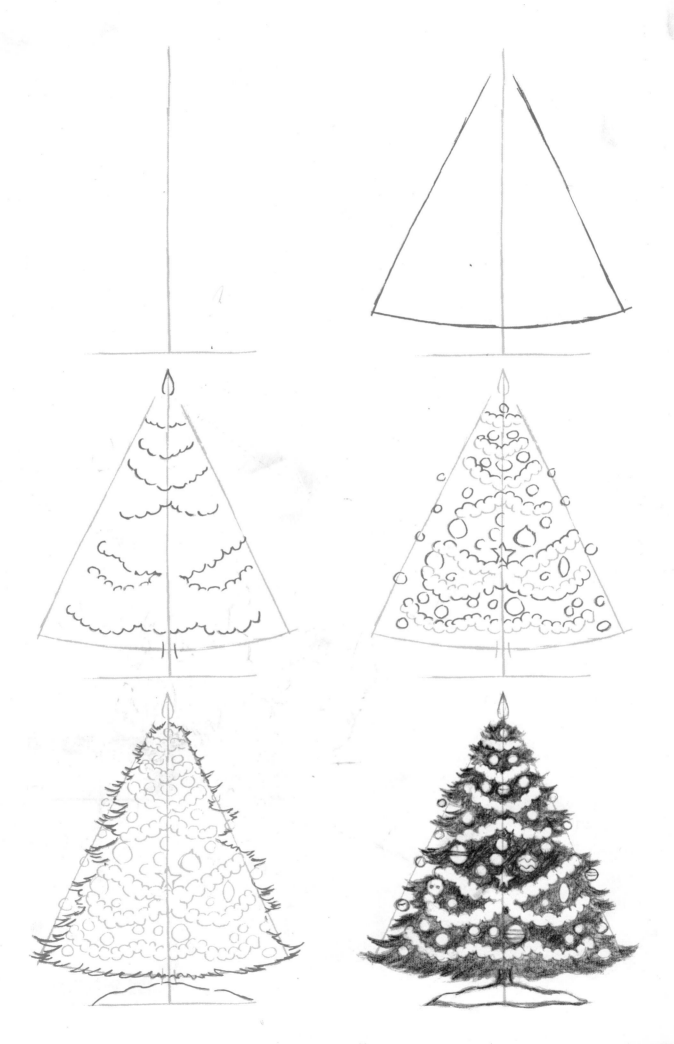

Christmas

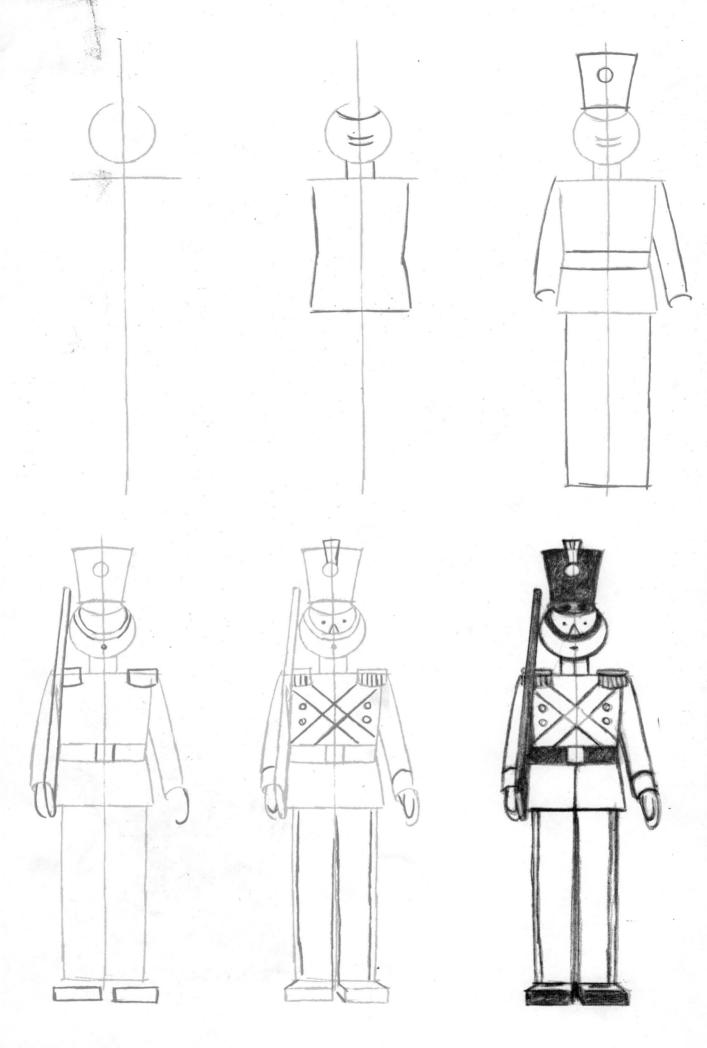

Christmas

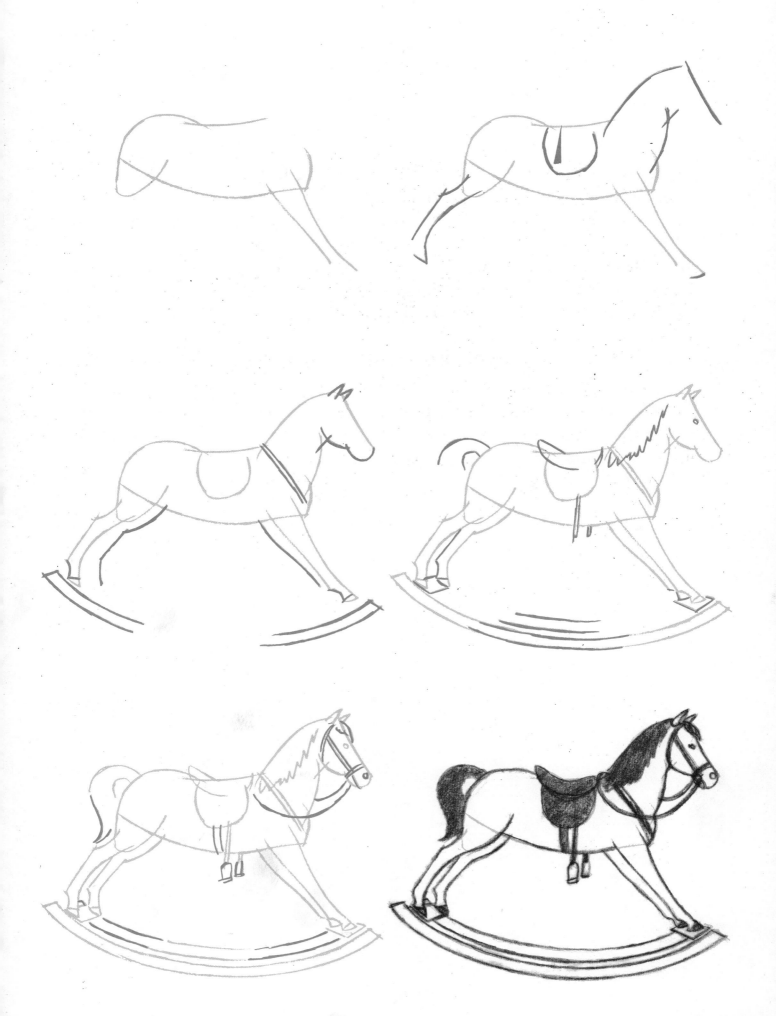

Christmas

LEE J. AMES joined Doubleday's Books for Young Readers list in 1962 and has been "drawing 50" ever since. His popular Draw 50 books, which utilize a unique step-by-step method to guide the young artist's hand have sold *over one million copies* to date. Before he came to Doubleday, Lee's experience ran the gamut from working at Walt Disney Studios to teaching at New York City's School of Visual Arts to running his own advertising agency. In addition, he has illustrated over 150 books from preschool picture books to postgraduate texts.

Lee and his wife, Jocelyn, live on Long Island, New York.

RAY BURNS has worked as a free-lance illustrator since 1966. During that time he has illustrated close to seventy children's books, worked as a cartoonist, and created storyboards for television. An ex-naval officer, Ray now lives in Wilton, Connecticut, with his wife, Doris, and their three children.